ANNIE LEIBOVITZ AT WORK

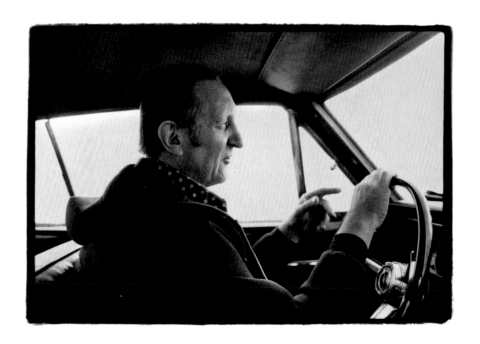

Samuel Leibovitz, Silver Spring, Maryland, 1972

Marilyn Leibovitz, Dulles International Airport, Virginia, 1972

To my family. My first subjects.

Rachel Leibovitz, Waterbury, Connecticut, 1974

ANNIE LEIBOVITZ AT WORK

RANDOM HOUSE NEW YORK

Self-portrait, San Francisco, 1970

W hen I was young and just starting out as a photographer, I worked for *Rolling Stone,* which was then a small magazine published in San Francisco. It was devoted mostly to rock and roll. I didn't actually know much about rock and roll, but I was grateful to be able to take pictures and see them published. It didn't matter what the subject was. What mattered was photography. Being a photographer was my life. I took pictures all the time, and pretty much everything I photographed seemed interesting. Every single time I went out to take a picture was different. The circumstances were different. The place was different. The dynamics were different. Every single time. You never knew what was going to unfold.

Years before it ever occurred to me that one could have a life as a photographer, I had become accustomed to looking at the world through a frame. The frame was the window of our family's car as we traveled from one military base to another. My father was a career Air Force officer, and whenever he was transferred, which was often, our family of six kids would pile in the back of the station wagon and my mom and dad would just drive, nonstop. We didn't have any money, so motels were pretty much out of the question. I remember driving from Fairbanks, Alaska, to Fort Worth, Texas.

Our luggage was piled on top of the station wagon, and a set of moose antlers was in front of the luggage. We stopped only once, in Anaheim, to see Disneyland. The Disneyland people let us park right in front of the entrance.

I was a third-year student at the San Francisco Art Institute when my pictures began appearing in *Rolling Stone*. I had enrolled there as a painting major in the fall of 1967. My father was by then stationed in the Philippines, at Clark Air Base, the largest American military base overseas. It was the main support base for soldiers coming in and out of Vietnam. During the summer after my freshman year, while I was staying with my family at the base, I visited Japan with my mother and some of my brothers and sisters. I bought my first real camera in Japan, a Minolta SR-T 101. The first thing I did with it was take it on a climb up Mt. Fuji.

Climbing Mt. Fuji is something every Japanese does at some point, but it's harder than you might think. I was young, and I started up the mountain fast. I didn't know about pacing. My brother Phil was even younger—he was thirteen—and he ran ahead of me. Phil disappeared. The camera felt like it weighed a ton. It was awkward. It got heavier the higher we went. After a while I was pretty sure I wasn't going to make it, but just then a group of elderly Japanese women in dark robes came marching along in single file. They were chanting in an encouraging way and I fell in behind them. We passed Phil at the seventh way station. He was lying flat on his back.

When you climb Mt. Fuji you stay overnight at the eighth way station and get up in the morning so that you can reach the top at sunrise. It's a glorious moment. Spiritually significant. When I got to the top I realized that the only film I had was the roll in the camera. I hadn't thought much about the film situation. I photographed the sunrise with the two or three frames I had left.

I took this, my first experience with a camera on the road, or path, as a lesson in determination and moderation, although it would be fair to ask if I took the moderation part to heart. But it certainly was a lesson in respecting your camera. If I was going to live with this thing, I was going to have to think about what that meant. There weren't going to be any pictures without it.

That summer, I took pictures around the base and developed the film in the base hobby shop. When I went back to the San Francisco Art Institute I signed up for a night class in photography. The following summer, I took a photography workshop, and that's when I decided that this was what I wanted to do. Photography suited me. I was a young and unformed person and I was impatient. Photography seemed like a faster medium than painting. Painting was isolating. Photography took me outside and helped socialize me. I felt at home in the rooms where the photography students worked. There were a lot of angry abstract expressionists in the painting studios. I wasn't ready for abstraction. I wanted reality.

We were taught that the most important thing a young photographer can do is learn how to see. It wasn't about the equipment we were using. I don't remember being taught any technique. A camera was only a box that recorded an image. We learned to compose, to frame, to fill the negative, to fit everything we saw into the camera's rectangle. We were never to crop our pictures. We went out every morning and took pictures and developed them in the darkroom the same day. Since the prints were washed in communal trays and everybody's pictures were lying there with everybody else's, you tried hard to come back with something good. In the evening we would sit around and discuss our work. We were a community of artists.

Henri Cartier-Bresson and Robert Frank were our heroes. *The World of Henri Cartier-Bresson* had just been published, and I remember looking at that book and realizing what it meant to be a photographer. The camera gave you a license to go out alone into the world with a purpose. Robert Frank was probably the most influential figure among the photography students. A new edition of *The Americans* had also just been published, and I fell in love with the idea of working like Robert Frank. Driving around in a car and taking pictures. Looking for stories. Danny Lyon's book about motorcycle gangs, *The Bikeriders*, was another important book at the time. Lyon was not much older than we were and he had lived with the bikers he photographed, gotten close to them. It was this style of personal reportage, shot in black and white with a 35mm camera, that we adopted.

In retrospect, there are two photographs that represent the way I wanted

13

to work—the romance of the process. One is the last photograph in *The Americans*. Robert Frank's wife and two small children are in the front seat of their car. It's dawn. They're parked across from a truck stop in Texas. You can imagine that they've been driving all night. The picture is from one of the trips Frank took across the United States, making a record of the country as if, as he put it, he were someone who was seeing it for the first time. The other photograph is a picture of Irving Penn's portable natural-light studio. It was taken by his assistant in 1967 on a desolate plain in Nepal. The studio is a big rectangular tent partially supported by ropes pegged into the ground. Penn's truck is parked in back of it. This was the studio Penn took on his expeditions to remote places. He used it to photograph the Mud Men of New Guinea and the Quechua Indians in the Andes and tribesmen in Morocco.

In the fall of 1969, I took my camera with me to Israel, where I worked on a kibbutz and studied Hebrew. I thought about staying there. The Vietnam War was at its height, and it was a confusing time to be a young American. It seemed particularly confusing to me, personally. I was a member of the generation that was most vocally opposed to the war, and yet I felt that I should be loyal to my father, who was going in and out of Vietnam on missions. It became apparent pretty soon, however, that becoming an expatriate wasn't going to solve anything. I had a home and a country. At the beginning of the year I went back to the San Francisco Art Institute and began printing my pictures from Israel in the school darkroom and going out every morning to take more pictures.

The scale and violence of the protests against the war had increased while I was away. In the spring of 1970, students went on strike to protest the invasion of Cambodia. The ROTC building at Kent State University in Ohio was burned down, and National Guardsmen fired into a crowd of students, killing four of them. I had taken pictures of antiwar rallies in San Francisco and Berkeley, and my boyfriend persuaded me to take them to the art director of *Rolling Stone,* along with my pictures from Israel. One of the pictures of a demonstration at City Hall was used for the cover of a special issue of the magazine devoted to campus riots and protests. It was

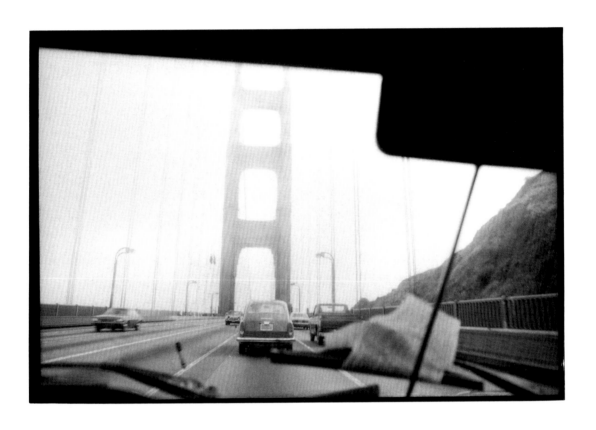

Golden Gate Bridge, San Francisco, 1977

the beginning of my career. Seeing that image on the newsstand is a moment that will stay with me forever.

By the summer between my junior and senior years at the art institute I had traded my Minolta in for a Nikon, the camera of choice for professional photographers in the late sixties and early seventies. The Nikon had a really sharp 35mm lens. A free-flowing, beautiful lens. During the early years at the magazine, when I thought of myself more as a photojournalist than a portraitist, I usually carried three cameras on assignments. I didn't want to lose time changing lenses. I would take a 35mm lens, a 55, and a 105. A 35mm lens provides a perspective close to what the human eye sees, and it was my lens of choice. The 55 was considered a "normal" lens, very classic, simple, and noninterfering. The 105 was on a body with a meter and I could use it for light readings. Zoom lenses were not really an option then. They weren't made very well. When you saw a photographer with a zoom lens on his camera you didn't take him seriously.

In the early years at *Rolling Stone,* the art department thought nothing of cropping photographs or cutting them up and making collages. Or running them very small. The editors were more interested in the text than in pictures. I took it almost as a personal triumph in 1976 when the magazine devoted a whole issue to Richard Avedon's portraits of people he considered to be at the center of power in America. They had asked Avedon to cover the presidential elections that year—Jimmy Carter was running against Gerald Ford—but he wanted to do something more ambitious, and they let him. They published seventy-three pictures in a portfolio called "The Family." There were portraits of Henry Kissinger; Rose Kennedy; the Joint Chiefs of Staff; Ralph Nader; Ronald Reagan; the investigative journalist I. F. Stone; and Rose Mary Woods, Nixon's secretary, who claimed to have accidentally erased several minutes of taped conversations about Watergate.

"The Family" showed how the power of photography and the power of a magazine can be harnessed together. A magazine is a blank canvas. One rarely gets the opportunity to use it to the extent Avedon did in 1976, but if you work for a magazine you're always thinking of the possibilities. Avedon knew what the potential was and he ran with it. *Rolling Stone* was probably

the only place he could have done that then. It was a relatively young magazine. Flexible. At the time, it was published in a tabloid size, almost the size of the old *Life* magazine. Avedon's pictures were in stark black and white, and they reproduced well on newsprint.

Avedon was the preeminent magazine photographer of his time. I knew his work because I studied the fashion magazines that were sold on certain newsstands in San Francisco and Los Angeles. I wasn't interested in fashion, but I would stand in front of the newsstand on Las Palmas, near Musso & Frank, in L.A., for hours, looking at magazines published in New York and London and Paris and Rome.

Around this time I was contacted by Bea Feitler, who was working with Avedon and other photographers in New York. Bea had been an art director at *Harper's Bazaar* in the sixties, following in the footsteps of the legendary art directors Alexey Brodovitch and Marvin Israel. Marvin was Bea's teacher at the Parsons School of Design and he brought her to the magazine when she was only twenty-three. Marvin left two years later, and Bea and Ruth Ansel, another young designer, took his job. Bea knew what a good photograph was. What a good story was. Bea and Ruth were one of Diane Arbus's principal sources of assignments. When I met Bea she was the art director of *Ms.* magazine and was calling to ask me to do some work for them. We photographed Lily Tomlin with hair from my hairbrush glued to her armpit. That one didn't get past the editorial committee at *Ms.* Bea also designed dance posters for Alvin Ailey and worked with Boris Kochno on his book *Diaghilev and the Ballets Russes* and with Helmut Newton on *White Women.* She had eclectic tastes.

Bea and Avedon had edited a collection of Jacques-Henri Lartigue's photographs of his family and friends that they titled *Diary of a Century.* They included pages from Lartigue's handwritten diaries, drawings, and quirky pictures of his life in France, starting in 1904. *Diary of a Century* became my favorite photography book. When Bea told me that she and Avedon had made it up, I was disappointed, although I realize that what she meant is that they had collected Lartigue's material in a way that told a story. They had figured out a way to present it.

Bea taught me a great deal about presentation, but probably the most important thing she taught me was to edit my photographs and to be involved in the way they were used. I had started out as a young photographer schooled in the fine arts. You took a photograph when you felt moved to. But now I was working at a magazine, with an art director, and editors, and writers. I had to learn to make the most of an assignment. To use the magazine to my advantage. I had the nagging feeling that magazines were the wrong road, that working for one was selling out, but feeling guilty is not a bad thing. You should always question what you do. Sometimes I thought that I couldn't be doing anything better than publishing pictures in a magazine. It was such a powerful vehicle for them.

The people I worked with at *Rolling Stone* in those early years didn't tell me what to do. It never occurred to them. Most of the time I could respond to what was happening without preconceptions or an agenda. I was never thinking about the magazine when I was on the road. I was in the thick of it, and I made my own decisions based on what was possible. Things happen in front of you. That's perhaps the most wonderful and mysterious aspect of photography. It seemed like you just had to decide when and where to aim the camera. The process was linear and it never stopped. That's still true, although I've traded in my need for always taking pictures. I can let them go by sometimes now and just be there.

NIXON'S RESIGNATION

The San Francisco Art Institute had instilled in me a reverence for a very personal kind of photography, exemplified by Robert Frank and Henri Cartier-Bresson. I also admired the classic photo essays in the old *Life* magazine—stories like W. Eugene Smith's "Country Doctor," which was shot in a remote town in Colorado. In 1948 Smith spent a month with the doctor. He photographed him making house calls, delivering babies, stitching up a little girl who had gotten hit in the head by a horse, amputating an old man's leg, sitting with another old man who was dying. It was an intimate, moving portrait. But there wasn't much of a place for the photo essay in *Rolling Stone* when I began working there in 1970. The magazine was edited by young people with newspaper backgrounds, assuming they had any prior professional experience at all, and the layouts were dominated by text.

The first issue of *Rolling Stone* had come out in the fall of 1967, a few months after the Summer of Love. The editor, Jann Wenner, was a music fan, and in the early years of the magazine's life, *Rolling Stone* was mostly about rock and roll, although it was never *just* a music magazine. It was about the culture around the music. By the time I arrived, more political stories were being assigned. It was hard to avoid politics in the early seven-

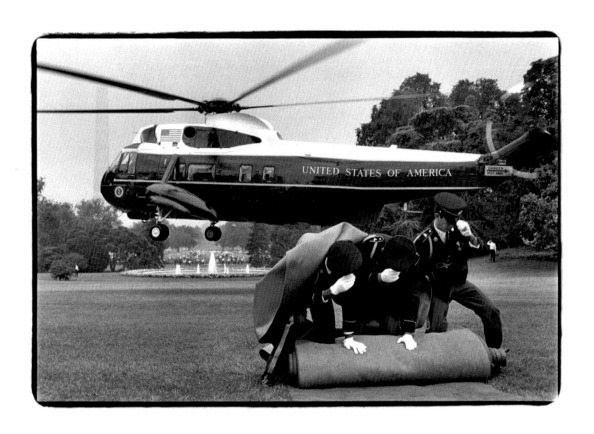

Richard Nixon leaving the White House, Washington, D.C., 1974

ties in San Francisco. It was a politically charged place. The Summer of Love had been the end, not the beginning, of flower-power culture. Things had turned dark. You could get mugged in Haight-Ashbury now. As for the music, I'd missed the most important moment. I had never photographed Jimi Hendrix or Janis Joplin, both of whom died in the fall of 1970.

Hunter Thompson showed up at *Rolling Stone* about the same time I did. He came to the office with a six-pack of beer to pitch a story about running for sheriff in Aspen on the Freak Power ticket. Hunter was inventing gonzo journalism. He was very charismatic, and on some level I was in love with him. Everybody was in love with Hunter. So I just jumped in the car and went along with him for a while. The problem was that Hunter didn't really want anyone working with him. He got his stories by sitting in bars and talking to people. A photographer who hung around would get in the way. Half the time Hunter's sources didn't know he was reporting. They thought he was socializing. The only time I remember him asking me to pick up my camera was one beautiful moonlit night when we were driving north on Highway One with no headlights on. A policeman stopped us, and when he started to give Hunter a sobriety test, Hunter pulled me out of the car and told me to take pictures. When I started taking pictures the policeman let us go.

Hunter seemed totally nuts to me. But I was young and inexperienced and he was seasoned. He skipped the traditional ways of gathering information and understood on a larger scale what was important. As crazed as he was, he knew what he was doing. He taught me that good reporters don't travel in packs. He never worked with another photographer. He didn't really work with me either, for that matter, although he called me from Las Vegas once and asked me to meet him and Oscar Acosta when they were working on the story that would become *Fear and Loathing in Las Vegas*. I didn't make it out there then, but Hunter and I covered the presidential campaign together in 1972. Hunter never talked to me about the stories we were working on. He pushed me away, and by pushing me away, he forced me to look at things myself. Hunter helped teach me how to see.

On one level, Tom Wolfe operated very much like Hunter did. Tom got

his stories from odds-and-ends moments. But Tom wasn't at all like Hunter temperamentally. Tom was very proper. He always wore long-sleeved shirts, and even if it was ninety-five degrees out and a hundred percent humidity he never sweated. Everyone was sweating through their clothes and Tom was completely dry. Hunter sweated a lot. When he wasn't sweating he was screaming that he wasn't sweating and he thought he was dying.

I went with Tom to Florida to cover the launch of *Apollo 17*, NASA's last manned flight to the moon. That's when Tom started doing the research on astronauts that led to *The Right Stuff*. It was interesting to be with Tom because you got in everywhere. There were all these parties before the launch.

The situation at the launch site was intimidating. The other photographers were working in teams with sixteen cameras and tripods and long, long lenses. The camera companies had set up kiosks where you could borrow lenses, and I think I managed to secure a 500mm lens for the lift-off shot, but I didn't really know what to do with it. I couldn't decide on the most fundamental thing, which was whether to photograph the people's faces as the rocket went up or the rocket itself. I had pretty much decided not to shoot the lift-off because everyone else was going to do that, but when it actually occurred it was such a dramatic event that I couldn't help but turn around and take the picture. When you watch a launch on television you don't realize how powerful the sound is. It travels in waves. The whole experience is very humbling. I found myself crying and holding on to the person next to me.

The stories I was doing back in San Francisco were just as thrilling to me as the moon launch or the presidential campaign. I couldn't believe that my job was to photograph musicians. I was a fan. When I was a student I had worked for a disc jockey, Edward Bear, at KSAN, a free-form radio station. He had the 2 AM to 6 AM slot. I would make tea and pull records for him. He did great mixes. He would segue into Aretha Franklin or Etta James from Martin Luther King's "I Have a Dream" speech. Because there was no advertising in the late time slot, his mixes could go on forever.

The first cover story I worked on was about Grace Slick. Ben Fong-

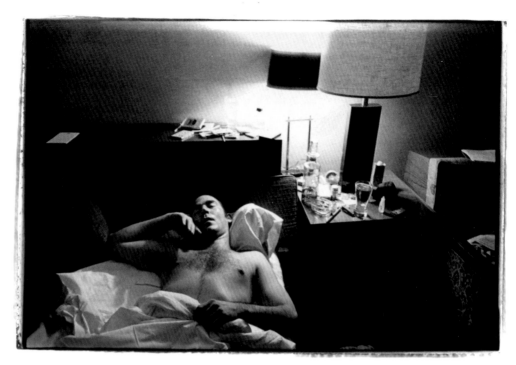

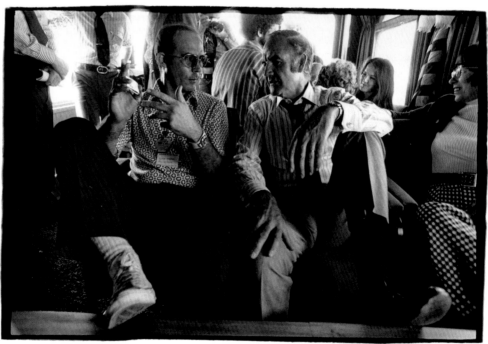

Hunter S. Thompson, Washington, D.C., 1972

Hunter S. Thompson and George McGovern, San Francisco, 1972

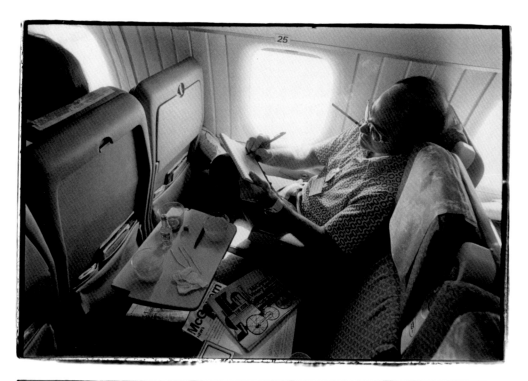

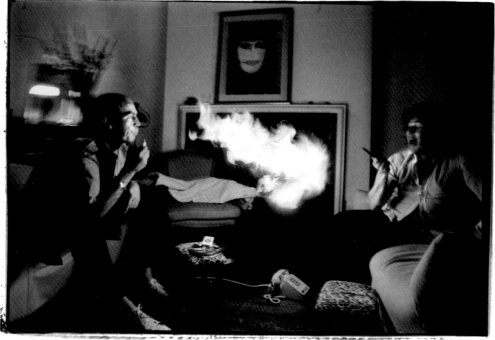

Hunter S. Thompson, California, 1972

Hunter S. Thompson and Jann Wenner, New York City, 1976

Tom Wolfe, Florida, 1972

Torres was the writer and I went with him to the Jefferson Airplane's house near Golden Gate Park. Grace Slick and Paul Kantner were in one of the back bedrooms. I took pictures while Ben was doing his interview. He was sitting on the edge of the bed. I liked taking pictures when the subject was occupied with the writer. In the photograph of Ray Charles in a hotel room in San Francisco you can see Ben's hand holding his microphone.

I worked with David Felton a lot. He taught me to appreciate the Beach Boys. And he introduced me to comedy, to the genius of Richard Pryor and Steve Martin and Lily Tomlin. David and I would talk through the stories late into the night. We shared our information. Most of the time, however, I worked with the subjects by myself. When Ben Fong-Torres was writing a story on Ike and Tina Turner, I went alone to photograph them at their house. There were vats of white powder lying around. Cameras in all the rooms fed back to Ike's room. There was a lot of stuff going on, but Ike was very friendly and I took my pictures and left. When I got back to the office I told Ben some of what I'd seen. I don't think I told him everything, but he put some of the details in his piece. When it was published, I got a call: "Annie, this is Ike. How could you have done that? We have ways to take care of people like you." I decided that from then on the writer's story was his story and my story was my story.

Writers, particularly writers with newspaper backgrounds, are used to working with photographers who come along with them to illustrate their stories. But a photographer may see different things than the writer does. I don't think it matters if your pictures don't match in a literal way what the writer brings back. The story might be better—fuller—with different points of view. If it's a good story, the writer and the photographer won't be that far apart.

Nixon's resignation was the last story I worked on with Hunter. He had been railing against Nixon since 1968 and now, in the summer of 1974, the guy was about to be defeated. When Nixon came out to California in July, Hunter and I were invited to a strange cocktail party for the press at San Clemente. Hunter gave me some mescaline. I took mescaline maybe twice in my life, but when you were in Hunter's world you did what he did. The

event was off the record, although I didn't know what that meant then. I was taking pictures because it seemed like the thing to do and I couldn't understand why people were looking at me strangely. Ron Ziegler, Nixon's press secretary, was wearing shorts. There was a banner on the wall that read, Hang In There Mr. President.

Two weeks later we were in Washington to cover the end. I had been one of the last journalists to be given credentials to get into the White House, and I was waiting there. Hunter was back at the hotel. Every reporter on the planet was at the White House, and Hunter was in the swimming pool at the Hilton with a battery-powered TV set. When Nixon walked down the red carpet toward the helicopter that would take him away, there were dozens of press photographers, most of them shooting with long lenses to get in tight, since the news magazines didn't have room for large pictures. Everyone pretty much moved away after Nixon was inside the helicopter and the door was closed. The guards began rolling up the carpet. It wasn't the kind of picture that most magazines would want to run or had room to run then, but a lot can be told in those moments in between the main moments.

When it became apparent to the editors at *Rolling Stone* that Hunter was not going to file a story in time, they decided to run my pictures as the story, along with some old pieces we had published on Nixon. I had the cover and eight pages of pictures inside. Hunter's story ran two issues later and was pegged to Ford's pardon of Nixon. It was very long and included a scene Hunter concocted in which he gets out of the swimming pool and takes a cab to the White House and arrives at the Rose Garden, where he pushes through a throng of photographers and goes up to the helicopter and starts to get in. Just then Nixon walks up. Hunter gives him a nod and lights a cigarette and watches Nixon make a V sign with his arms and fall back into the helicopter. It lifts off with an enormous roar. A blast of air from the rotors blows all the photographers off balance.

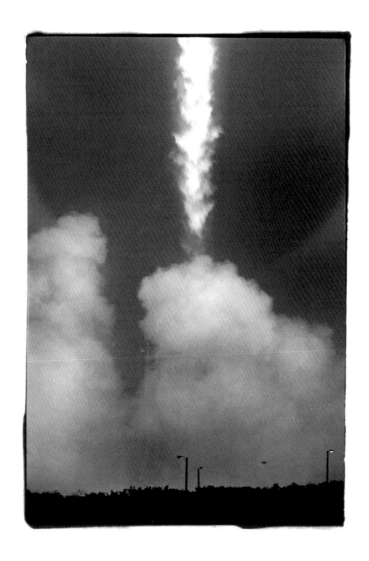

Apollo 17, the last moon shot, Cape Kennedy, Florida, 1972

THE ROLLING STONES

When I first worked for *Rolling Stone,* we wouldn't photograph a band until they came to town. I hardly ever traveled. I took some pictures of the Rolling Stones when they came through San Francisco in 1971 and 1972, and I remember going down to L.A. when they were rehearsing. I had a cockamamie idea about photographing them in a car, and my friend the writer Eve Babitz told me that Tuesday Weld owned a gold Cadillac. So we borrowed the Cadillac from Tuesday Weld. I had discussed it with Mick on the phone. He thought it was a good idea. He was probably thinking about Elvis Presley or something. The band was practicing on the Burbank lot, and they all came out and looked the car over. They said it was a bad year. "Cars are like wine," Mick explained to me. "There are good years and bad years." And they walked away.

Truman Capote was supposed to write a story about the 1972 tour for the magazine, and Jann said it was OK if I went along to two or three cities. Robert Frank was traveling with the band, making a 16mm film that would become *Cocksucker Blues.* The band had commissioned him to do it, but it was never released, presumably because of the drugs and sex that were filmed. Danny Seymour, Frank's friend and camera assistant, was involved in a lot of that. He died mysteriously while the film was being edited.

Rolling Stones fans, Cleveland, Ohio, 1975

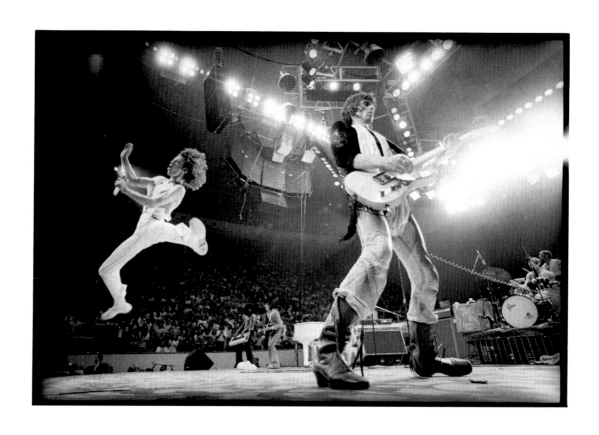

The Rolling Stones, Philadelphia, 1975

I was in awe of Robert Frank. Here was the great master. I couldn't believe that I was able to watch him work for a few days, that I was actually in the room where Robert Frank was loading his camera. He picked up my camera once. I was terrified. He held it. It was like being with God. He said to me, "You can't get every picture." That was comforting advice. You do miss things. You're attached to this machine. To its timing. Things are moving in front of you and you're supposed to capture them, but it's not always possible. Robert Frank didn't seem to be missing anything, though. He was tireless. He never stopped working.

I guess the band liked the few pictures I took then, and three years later Mick called and asked me if I would like to be their tour photographer. Mick is very shrewd. He understands that the documentation of the band is important. He kept all of his costumes from the tours. And he's always had a photographer. Like the President or the Queen has a photographer.

Mick asked me to be their Cartier-Bresson. I'm not sure what he meant by that. I think he wanted me to come along because I was young and might liven things up. It would be an interesting mix. Certainly there were other photographers who were more involved with music and more interested in living the life musicians lived than I was. Jim Marshall, for instance. He hung out with musicians. They were his friends. Bob Seidemann had taken the famous photograph of Janis Joplin wearing nothing but several strands of beads, with her nipple exposed. And it was his photograph of the naked red-haired girl looking like she had been painted by Botticelli on the Blind Faith album cover. Bob also did posters for the Fillmore. David Gahr had been photographing musicians for years. He loved music. He had been at the Newport Folk Festival in the early sixties and had photographed Dylan and Springsteen and Miles Davis. Baron Wolman had been the chief photographer at *Rolling Stone* in the beginning.

I admired these photographers, but I found concert work difficult. You never could take your eye from the camera and you were at the mercy of the lighting people, who were usually on drugs. Plus you had to be prepared to be crushed by the audience. At the end of the concert they would invariably rush the stage, and if you were in front you had to get ready for that.

Two songs before the end, I would put all but one of my cameras in my bag and secure the flaps and strap the bag across my chest. Eventually the wave would subside, but you could be carried along for several feet before that. I remember an Aretha Franklin concert where I was pushed practically onto the stage. You had to just let your body go loose and not fight it.

Nevertheless, I went to Jann and told him I wanted to go on the Rolling Stones tour. He said that he couldn't guarantee that there would be a job for me when I came back, but I thought it was too good an opportunity to miss. Robert Frank had photographed the Rolling Stones and now it was my turn.

The band was rehearsing at Andy Warhol's place in Montauk, at the end of Long Island, and I went out there for a month or so, and then there was a break, and the tour started in June. I was very naïve. I brought my tennis racket with me. I thought that as we went from city to city I would take tennis lessons. I didn't know what I was getting myself into. They were paying me a few hundred dollars a week and I was supposed to create publicity pictures, but I only managed to get a couple out the first day and that was it. I was never up during the day again. I was always with the band.

At the time, I thought that the way to get the best work was to become a chameleon. To become so much a part of what was going on that no one would notice you were there. Of course it was unbelievably stupid of me to pick that situation to become part of. I did everything you're supposed to do when you go on tour with the Rolling Stones. It was the first time in my life that something took me over.

A rock and roll tour is unnatural. You're moving through time and space too fast. The experience is extreme. There is the bigness of the performances and then the isolation and loneliness that follow. The band was like a group of lost boys, but their music saved them. It gave them a reason to exist. When they weren't on tour they didn't spend that much time together. On the road they worked. Mick and Keith didn't always talk to each other. Keith's guitar was supposed to be amplified as loud as Mick's voice. They were caught up in a romantic struggle. It was the first time in my life—and I'd been at *Rolling Stone* for five years by then—that I saw how music is made. I saw

Keith Richards, Toronto, 1977

how it is produced organically. The riffs I heard in hotel rooms during the tour were the songs on the next album—"Memory Motel," "Fool to Cry."

The photograph that is emblematic of the 1975 tour for me is the one of Mick in the elevator. It was toward the end of the tour, and he was not on the ground. He was flying. From another world. He was the most beautiful object. Like a butterfly. Ethereal. After all the time on the road, his dancing was very loose. It was almost surreal. I was always aware of where Mick was. What might have seemed like a nuisance to him became a source of comfort. To know that I was somewhere nearby. It was a subject/photographer relationship of an obsessive kind. I remember him saying that I should tell him if I wanted him to be at a specific place on the stage at any point in the show, but I found that too daunting. I couldn't think of anything for him to do that he wasn't already doing.

At the end of the performances, there were two or three encores that had been planned. Nothing was ad-libbed. The band was professional in a way I hadn't seen before. They'd been doing it awhile. And they were always concerned about putting on a good show, no matter how huge the hall was. After the last encore, when everyone in the audience thought they were coming onstage again, they would get out of Dodge. Mick dumped several pails of water on his head every night and he would leave the stage totally wet, with his eye makeup running. He wrapped himself up in towels and jumped in the car. Usually the band went straight to the plane, but we were staying in town the night I photographed him in the elevator. The photograph was taken on the way up to Mick's room. He and I were alone. We were on some level out of it. Not because of drugs, but because of all that travel, and sleep deprivation, and the exertion of the performances.

I learned about power on that tour. About how people in an audience can lose a sense of themselves and melt into a frenzied, mindless mass. Mick and Keith had tremendous power both onstage and off. They would walk into a room like young gods. I found that my proximity to them lent me power also. A new kind of status. It didn't have anything to do with my work. It was power by association.

I shot hundreds of rolls of film on the tour. A few pictures were published

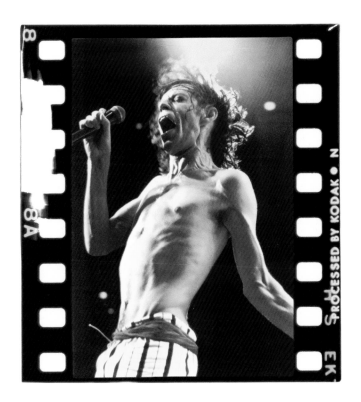

Mick Jagger, Chicago, 1975

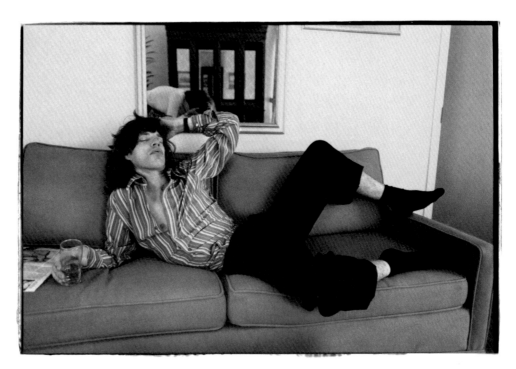

Mick Jagger, San Francisco, 1975

Keith Richards with his son, Marlon, Toronto, 1977

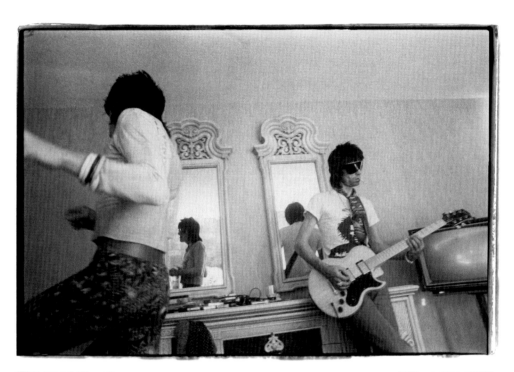

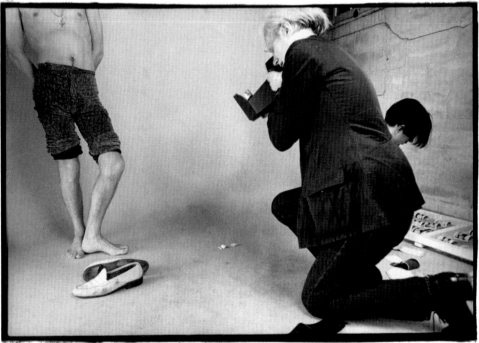

Ron Wood and Keith Richards, Jacksonville, Florida, 1975

Mick Jagger, Andy Warhol, and Fred Hughes, Montauk, New York, 1975

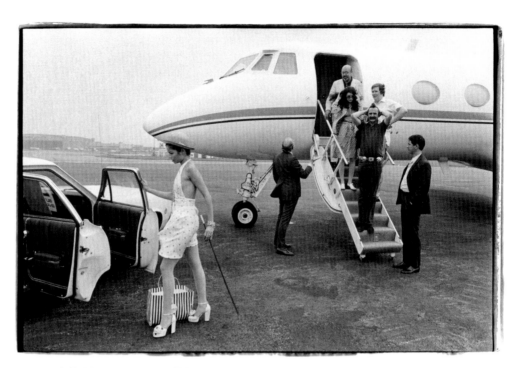

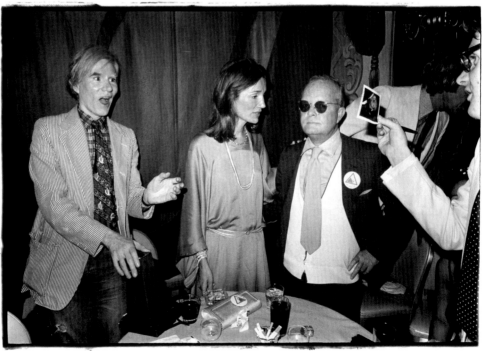

Bianca Jagger, Ahmet Ertegun, Lord Hesketh, and Earl McGrath, New York, 1972

Andy Warhol, Lee Radziwill, Truman Capote, and Vincent Fremont, New York City, 1972

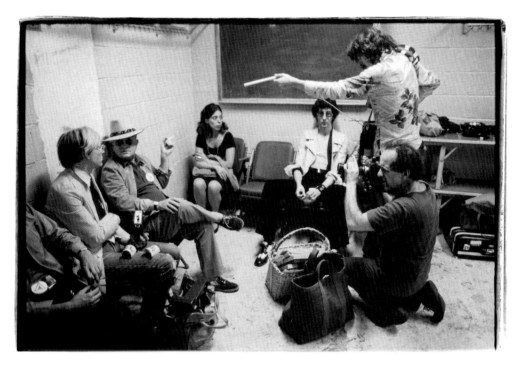

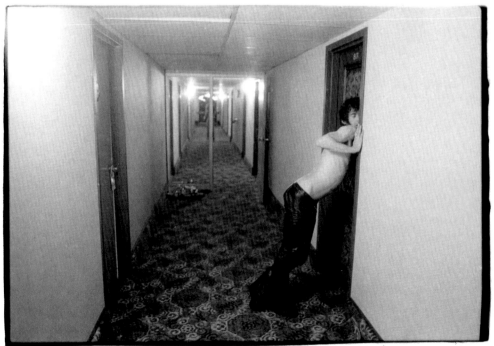

Andy Warhol, Truman Capote, Danny Seymour, and Robert Frank, New Orleans, 1972

Keith Richards, Buffalo, New York, 1975

in *Rolling Stone,* but I didn't look at most of them until years later, when I was putting together the book and exhibition of my work from 1970–1990. I included a few of the photographs and tried to convey how hard it all was, but I don't think I succeeded in getting that across. The more I tried, the more romantic the pictures seemed.

I've been on many tour buses and at many concerts, but the best photographs I've made of musicians at work were done during that Rolling Stones tour. I probably spent more time on it than on any other subject. For me, the story about the pictures is about almost losing myself, and coming back, and what it means to be deeply involved in a subject. The thing that saved me was that I had my camera by my side. It was there to remind me who I was and what I did. It separated me from them.

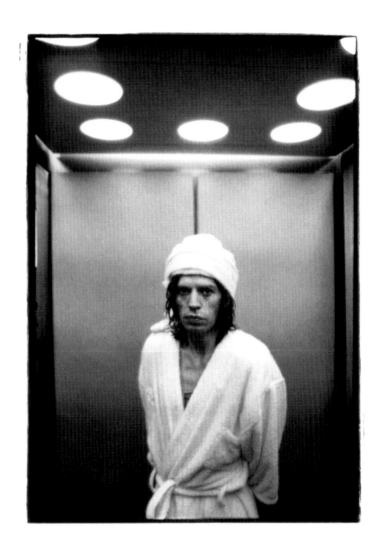

Mick Jagger, Buffalo, New York, 1975

JOHN AND YOKO

The picture of John Lennon and Yoko Ono lying on the floor together a few hours before he was murdered was ten years in the making. The first picture I took of John was my first important assignment from *Rolling Stone*, in 1970. Jann Wenner was going to New York to interview him, and I persuaded Jann that I should come too, mostly by explaining that I would be cheaper than anyone else. I flew youth fare and stayed with friends. Yoko said later that she and John were impressed that Jann let someone like me photograph people who were so famous. They were used to the best photographers in the world, and this kid showed up. But John didn't treat me like a kid. He put me at ease. He was honest and straightforward and cooperative. That session set a precedent for my work with well-known people. John, who was a legendary figure, someone I revered, taught me that I could be myself.

I was carrying my three Nikons, with the 105mm lens on the body with a light meter. At one point, while John was talking to Yoko, I was using the 105 to take a reading and John looked up at me. It was a long look. He seemed to be staring at me, and I clicked the shutter. That was the picture Jann chose for the cover when we got back to San Francisco.

Ten years later, John and Yoko's album *Double Fantasy* had just come out, and Jonathan Cott had done an interview with John for *Rolling Stone*.

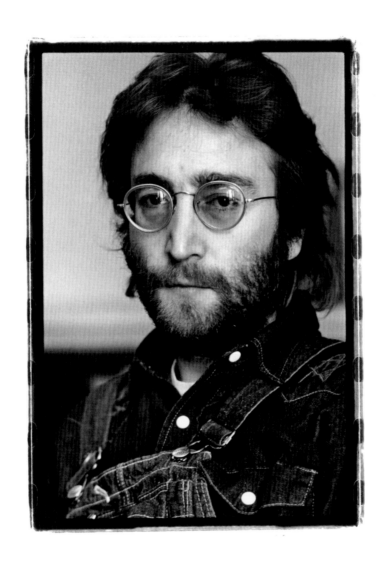

John Lennon, New York City, 1970

I photographed them at their apartment in the Dakota early in December, and then a few days later I came back with something specific in mind. John and Yoko were exchanging a kiss on the cover of the new album. It was a simple kiss in a jaded time. I thought about how people curl up together in bed, and I asked them to pose nude in an embrace. They had never been embarrassed about taking their clothes off. There was frontal nudity on the cover of *Two Virgins,* the first record they did together. They were artists. John had no problem with my idea, but Yoko said she didn't want to take her pants off for some reason. So I said, "Oh, leave everything on."

I made a Polaroid of them lying together and John looked at it and said, "You've captured our relationship exactly." He had just spent five years being what he referred to as a house husband, taking care of their young son, Sean, and the new album was his return to a musical career. He took me aside and said that he knew that the magazine wanted just a picture of him on the cover but that he wanted Yoko on the cover too. He said it was really important.

The photograph was taken in the late afternoon in a room overlooking Central Park. We were going to get together later to go over the transparencies, but that night, as John was returning home from a recording session, a deranged fan shot him. I heard the news from Jann. John had been taken to Roosevelt Hospital, and I went there and took a few pictures of the crowd that had gathered. Around midnight, a doctor came out. I stood on a chair and photographed him announcing that John was dead. Then I went back to the Dakota and stood with the mourners holding candles.

The picture looks like a last kiss now. Jann decided to publish it on the cover with no type on it except for the *Rolling Stone* logo. When I went to John and Yoko's apartment to show Yoko a mock-up, she was lying in bed in a dark room. She said she was pleased with what we had done.

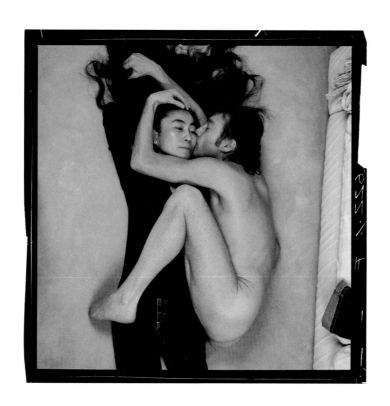

John Lennon and Yoko Ono, New York City, December 8, 1980

CONCEPTUAL PICTURES

While it is true that the art of photography relies on knowing how to use the camera to the best of its ability, it's also true that not knowing what you're doing is only a temporary and not necessarily crippling condition. You learn as you work, and you certainly can ask for advice. Larry Schiller was one of the photographers who gave me useful advice early on. Larry is an eccentric genius who has worn many hats—publisher, writer, filmmaker. I met him shortly after I began working for *Rolling Stone*. He was making a documentary about Dennis Hopper, who introduced us. Larry had worked primarily as a photojournalist in the sixties, and one of his favorite stories was about being sent to photograph the test of an ejection seat. This particular seat was designed for a plane that was on the ground, not in the air, and it required terrific thrust. The seat was going to be thrown up three hundred feet in a split second. Larry knew that he would get only about three frames of not very interesting film if he worked on the ground with the other photographers, so he had a 150-foot tower built and he put a remote-controlled 70mm camera on top of it. The camera was normally used for baseball games. For photographing fast-moving objects. Larry measured the wind velocity and calculated the likely arc of the seat, and when the seat shot out of the plane he got several frames of it coming straight at his lens.

Larry had another story that he liked to tell about figuring out how to photograph a plane exploding on the floor of the desert. They were testing the volatility of fuel. Larry attached a Nikon to the vertical stabilizer on the tail of the plane. He had a 250-exposure back for the camera so that he wouldn't run out of film if the plane didn't blow up right away. Everything worked beautifully. The Nikon survived the explosion, although it took three hours to find it where it was buried in the sand. The only problem was that Larry had forgotten to put the film in.

Larry was excited about those jobs. He was thrilled to have a problem to solve. He took something of minimal interest and made it interesting. Larry knew that you are limited only by your imagination.

I have always been curious about how other photographers make their pictures. How things are done. I began collecting photography books in a serious way in the late seventies and started studying the history of photography more carefully. I read about Eadweard Muybridge's motion studies, with the calibrated backdrops and multiple cameras with stereographic lenses that revealed the position of, for instance, a horse's feet in mid-gallop. And about Harold Edgerton's development of the strobe and his photographs of events that couldn't be seen by the naked eye—a bullet passing through an apple or a playing card, a hummingbird hovering. They were great moments in photography. Feats. And the photographs were beautiful. That galloping horse and Edgerton's photograph of a bullet slicing the Queen of Hearts in half are romantic pictures. Poets took those pictures.

I had rudimentary technical skills when I started working. I had never shot in color when *Rolling Stone* began printing four-color covers in 1973, although by then Jann Wenner had given me the title "chief photographer." When I shot in black and white, the printer who processed my film, Chong Lee, saved me. He would inspect the film under a red light in the darkroom and push it until he saw something. But he couldn't help me with color. The exposure is critical with color transparencies. One of the first cover pictures I took in color was a backlit photograph of Marvin Gaye in Topanga Canyon at sunset. It looked gorgeous when we were there. The Kodachrome transparencies looked great too. They were fine-grained, saturated, very beau-

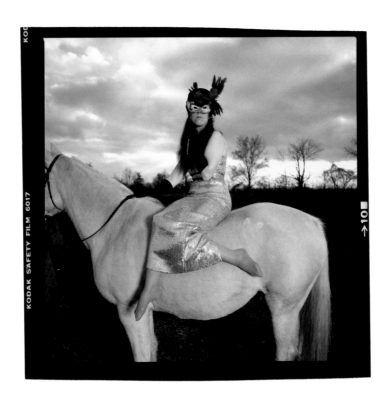

Tess Gallagher, Syracuse, New York, 1980

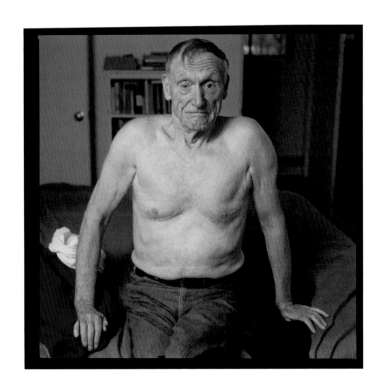

Robert Penn Warren, Fairfield, Connecticut, 1980

tiful. But the picture was a disaster when it was published. The ink sank into the newsprint and everything clogged up. All you could make out was the sunset. Marvin Gaye was in silhouette. There was no detail in his face.

To survive the printing process at *Rolling Stone,* I began adding strobes to natural light. This produced very graphic images in terms of form and color. There was a lot of contrast and color saturation in the pictures, but on the newsprint pages of *Rolling Stone* they were muted and off-register. I didn't realize how bright my transparencies actually were until my first book was published, in 1983. It was printed in Japan. I didn't have anything to do with choosing the printer. It never occurred to me that it made a difference—that Japanese printers are known for bright colors and that Italian printers have a palette that can make photographs look like Renaissance paintings. When I saw the first copies of the book I was shocked. The printer had reproduced the transparencies in a literal way. The pictures that had seemed fine when they were printed on newsprint looked garish on coated paper.

When I photographed the poet Tess Gallagher on the horse, I didn't have much control over the strobe. It lights her and then falls off in the background. There was just one umbrella light on a stand and it produced a crude effect. Other photographers—Diane Arbus, for instance—had used straight-on light in a much more sophisticated way to get the look they wanted. Arbus was a great admirer of Weegee's pictures of crime scenes and various catastrophic events and had studied them carefully. Weegee used an on-camera flash out of necessity. He was photographing at night and in dark rooms and other places where it was impossible to rely on natural light. Weegee was a newspaper photographer and he didn't care about the pictures being pretty. Arbus discovered that Weegee's work with the flash brought out the main thing you wanted to see and also revealed moments you hadn't anticipated. I wasn't thinking about any of this at the time, of course. I was just throwing up a light haphazardly and hoping the picture would come out.

That portrait of Tess Gallagher and the one of Robert Penn Warren are from a series on poets I made for *Life* in 1980. Tess Gallagher wrote about horses. She showed me a home movie she had shot on horseback. There were masks all over her house and coat racks full of clothes. She wanted to

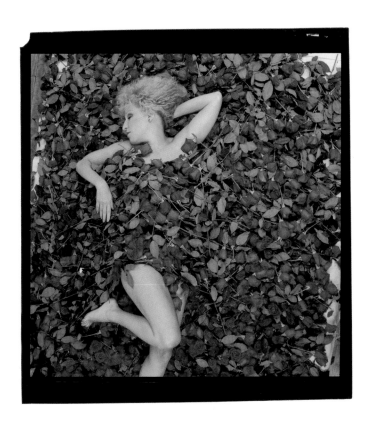

Bette Midler, New York City, 1979

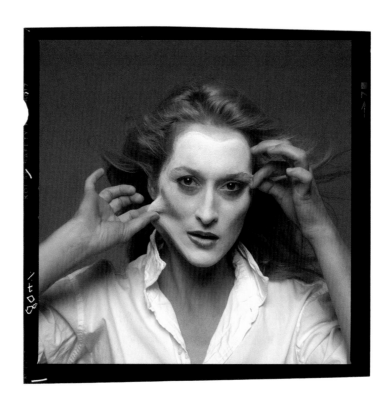

Meryl Streep, New York City, 1981

get dressed up and she pulled the sequined dress out of her closet. When you were with Gallagher you were in her world and you could see the way her imagination worked. The Tess Gallagher portrait is the beginning of placing my subject in the middle of an idea.

Robert Penn Warren had been writing about death. His poems are infused with an awareness of mortality, with the fleshiness and fragility of living things. The first time I visited him, I photographed him lying under a tree reading and in his office with his books. Conventional writers' poses. I knew I'd missed the picture, so I called him up a few days later and told him I'd like to come back. When I drove up, he was standing in the window of his bedroom, staring out at me. I asked him to sit on the bed and take his shirt off. I wanted to see under his skin, to see his heart beating, his lungs pumping. He didn't care whether the shirt was on or off. He was seventy-five then, very distinguished, with many awards for his novels and his poems, and he was at peace with himself.

The basic ideas for the portraits of Tess Gallagher and Robert Penn Warren came from reading their poems, from doing my homework. If I were preparing to photograph a dancer, I would watch him dance. I would listen to the musician's record. Somewhere in the raw material was the nucleus of what the picture would become. It didn't have to be a big idea. It could be simple. There's a case to be made that the simpler the idea the better. Putting blue paint on Dan Aykroyd and John Belushi, for instance. The first Blues Brothers album had gone double platinum, and they were taking themselves very seriously as musicians. I remember Belushi saying, "Did you hear Aykroyd on the harp? Better than Paul Butterfield!" Things were getting out of hand. I was thinking of them more as actors and comedians and I thought it would be funny to paint the Blues Brothers blue.

I told Aykroyd and the writer, Tim White, what I had in mind. Neither of them thought that Belushi would go along with it. We took the photographs in a bungalow in West Hollywood that looked like a motel room. In most of the frames they're just horsing around on a bed. Jumping up and down with their sunglasses on. Their faces aren't painted. Then I asked the makeup artist to put the blue paint on and I managed to shoot eight or nine frames

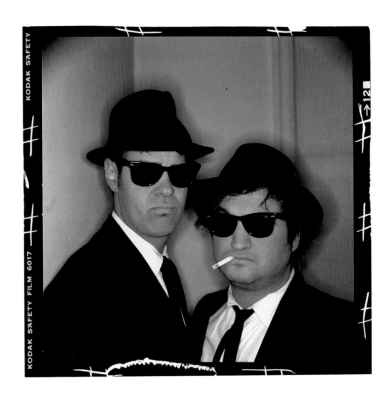

The Blues Brothers (Dan Aykroyd and John Belushi), Hollywood, 1979

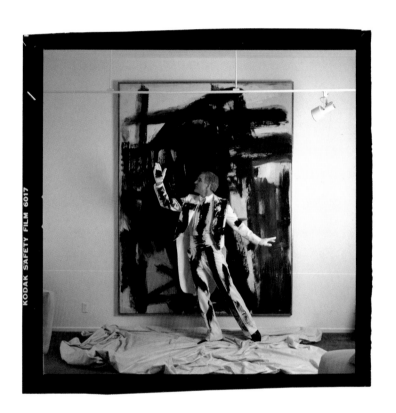

KODAK SAFETY FILM 6017

Steve Martin, Beverly Hills, 1981

before Belushi stalked off. He didn't think it was funny at all. He didn't speak to me for six months. I did a lot of that kind of thing when I was young and cocky. I wouldn't even know how to do it now.

The source of the picture of Bette Midler lying in the roses was also simple. Bette had a movie coming out, *The Rose,* which was loosely based on the life of Janis Joplin. She played the main character, Rose. Having her lie on a bed of roses seemed like a good way to create a background for the cover, although when I look at the picture now, it seems a little rough in terms of execution. She's underlit, and her body is at an awkward angle. We were winging it then. We hadn't thought about de-thorning the roses until an hour or so before Bette arrived, and we barely got them all clipped off in time. I got up on a ladder and took the picture. We were using Alex Chatelain's studio in New York. I didn't have my own studio. At that point in my career, it was helpful to rent other photographers' studios because I could see what kind of equipment was out there and how it was used.

I had begun using a 2¼ x 2¼ camera by this time to accommodate the change in the shape of the pages of *Rolling Stone.* After we moved to New York, in 1977, the magazine had been redesigned and had become wider. Almost a square. The larger format camera produced a square negative. It was also more appropriate for shooting prearranged, set-up portraits. If the subject was in one place and could be lit, there really was no point in taking the picture with a 35mm camera. The 35mm cameras were small and portable and appropriate for reportage, for moving around quickly. But the 2¼ negative produced more detail, which was a mixed blessing for me. You see everything a lot clearer in a bigger negative. Depth of field and lighting become more critical. You really have to focus. The 35mm negative had masked a lot of technical inadequacies.

The picture of Meryl Streep in whiteface was made during a session that didn't start out well. Meryl had only recently become a movie star. I had already done a fashion sitting with her for *Vogue,* and *Life* had used a head shot taken from that sitting on their cover a few months earlier. Francesco Scavullo had just shot her for the cover of *Time.* This round of publicity was for *The French Lieutenant's Woman.* Meryl was uncomfortable with all the

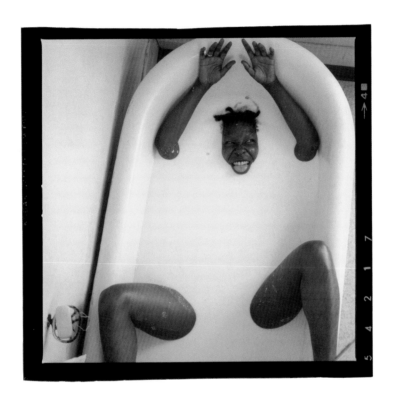

Whoopi Goldberg, Berkeley, California, 1984

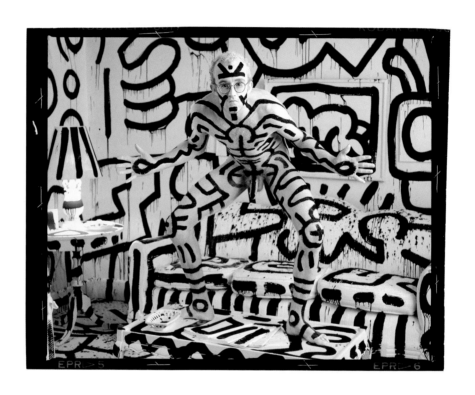

Keith Haring, New York City, 1986

attention she was getting and she cancelled the first appointment for the shoot, but she was finally persuaded to come to my studio for two and a half hours one morning. She came in and talked about how she didn't want to be anybody, she was nobody, just an actress. There were a lot of clown books lying around the studio and some white makeup left over from an idea I had had for either James Taylor or John Belushi. I told Meryl that she didn't have to be anybody in particular, and I suggested that maybe she would like to put on whiteface. To be a mime. That set her at ease. She had a role to play. It was her idea to pull at her face.

Steve Martin had just played the lead in *Pennies from Heaven* when I photographed him and he had developed his tap-dancing skills. That's why he's dressed in the white tuxedo and tails. He was collecting modern art, and he was particularly proud of a big Franz Kline painting he had just bought. When he showed me around his house he told me that he saw himself in the picture. I looked at it and saw what he meant. It was as complicated as he was. I decided that I could paint him black, like one of the brushstrokes, and put him in the painting. I wasn't sure this was going to work. I had tried something similar one time before with Mick Jagger and it had been a disaster. I had wanted to put Mick in a Turner painting. A late seascape. The person who came to paint him took about four hours and when she was finished he stood for thirty seconds and then said he was leaving.

I hired a scenic painter from the Disney studios to paint Steve Martin. She came over to the house, looked at the painting, looked at Steve in the tux, and in about two swishes she had painted on the black brushstrokes. Then she said she had to go back to work and she left. The brushstrokes were perfect. She made that picture.

The portrait of Whoopi Goldberg was shot just as her career was taking off. She had had a big success with a one-woman show at a club downtown in New York. I had looked at some grainy tapes of her act and was drawn to one of her characters, a little black girl who thinks that she's white underneath. The little girl bathes in Clorox to get rid of the black. My original idea wasn't very good. I wanted to paint Whoopi white and let the paint drip off her. Then I thought she should be in a white bath. A photographer who worked

in advertising a lot said, Oh, use milk. Milk photographs as white really well. I met Whoopi in her house in Berkeley and looked at her bathtub. A friend of hers next door had a better one and we decided to use that. We heated pots of milk on the stove and poured them into the bathtub and Whoopi got in. I didn't know how it was going to look, but I kind of thought that she would be sitting up in the bath and scrubbing herself. She sat back, and suddenly we had a very strong image. It was a total surprise.

Most of my pictures that people consider exaggerated or visually extreme—like Whoopi in the bathtub, or the portrait of Lily Tomlin with hair from my hairbrush under her arm—were made with comedians, although one was a collaboration with an artist, Keith Haring. It was commissioned by a magazine in Florida that went out of business before the picture appeared. Keith and I had talked on the phone and I asked him if he had ever painted himself. He said no, although a couple of years earlier Andy Warhol had arranged for him to paint Grace Jones and to have Robert Mapplethorpe photograph her when Keith had finished. We decided that he would paint his torso for me. We shot in the studio, on a set constructed to look like someone's living room and then painted white. When Keith arrived he painted the room with black lines in less than forty-five minutes. Then he painted his upper body in about five minutes. When he came out of the dressing room he was wearing white painters' pants, but it just seemed obvious to both of us at that point that he should paint the rest of him.

It's hard to paint yourself. Keith did only the front. I loved the way he painted his penis. It was so witty, with an elongated line. The pictures took only a few minutes, and when we finished, Keith didn't want to stop. He said he felt dressed and wanted to go out. I suggested that we go to Times Square, which was a few blocks away. This was 1986, and it was still pretty rough. The peep shows and the porn houses were still there. In the car on the way over I told my assistants that we were going to have to work fast because we would probably get arrested. I photographed Keith in back of the statue of George M. Cohan in Duffy Square and in front of a bank. It was a cold winter night and this painted, naked guy was walking around, and nobody, including a couple of policemen who were there, paid any attention to us.

Creating a portrait with a strong concept was in part a response to taking so many cover pictures for *Rolling Stone*. I thought a cover picture should have an idea. I still do, although it's become more and more difficult to do conceptual covers. Covers have to sell magazines, and publishers are always trying to figure out what's effective and what isn't. The great master of the conceptual cover was the art director George Lois, who created so many legendary covers for *Esquire* in the sixties. When Muhammad Ali was convicted of draft evasion and stripped of his heavyweight boxing title, Lois had him photographed as the martyred St. Sebastian, with arrows sticking out of his body. He drowned Andy Warhol in a can of Campbell's soup.

In the early days at *Rolling Stone,* the subject of the cover was whatever Jann Wenner was interested in, or whatever story some writer had finally finished. Now covers are always pegged to something. And who's on the cover makes a big difference. For a while, Jann thought that all the *Rolling Stone* covers should be shot against a seamless white backdrop, in the style of Richard Avedon. There is a recurring idea that there should be some kind of formula for the cover—that all the covers should look the same and that familiarity sells. Not many chances are taken.

After the *Rolling Stone* cover picture of John and Yoko was published, I felt that it was important to try to keep up that kind of intensity. The next cover subject was Bruce Springsteen, whose album *The River* had just come out. *The River* is a very moving set of songs about memories of better times and about human fragility. I photographed Bruce skating on ice. He could barely ice skate, but he did it. I was thinking of that beautiful late-eighteenth-century painting of the skater by the Scottish artist Henry Raeburn, but the picture works on several levels. Simple portraits can convey concepts too. Cartier-Bresson took a photograph of Giacometti running in the rain with his coat pulled over his head. He looks like a Giacometti sculpture.

ADVERTISING

Advertising work did not come naturally to me. It was against the grain of the West Coast art-school philosophy that I'd started out with. I had worked for magazines for almost fifteen years before I took a few advertising jobs, and I took those first jobs simply because I was at loose ends. In 1983, I left *Rolling Stone* and signed a contract with *Vanity Fair*, thinking that the range of subjects would be broader at a magazine with wider cultural interests. But the editors of *Vanity Fair* didn't use me much. Irving Penn was doing the covers. Ruth Ansel, who was the art director at *Vanity Fair* then, took me aside and said that I should be spending some of my time on advertising. It was OK to do advertising. More than OK. It was something that you did if you were a professional photographer in New York. Ruth said that twenty-five percent of my work should be advertising.

I was rather shocked by this. I had been proud of myself for not taking ad work. Recently, as a favor to Sissy Spacek, I had taken a commission to do the cover of an album of country music she made after the success of *Coalminer's Daughter*, and I was miserable. I was getting paid and I felt that I had to do something that pleased Sissy. She never said I had to please her, but I thought that I should, and that threw me. But Ruth was persuasive, and I tried some advertising jobs, only to find them as confusing as I had

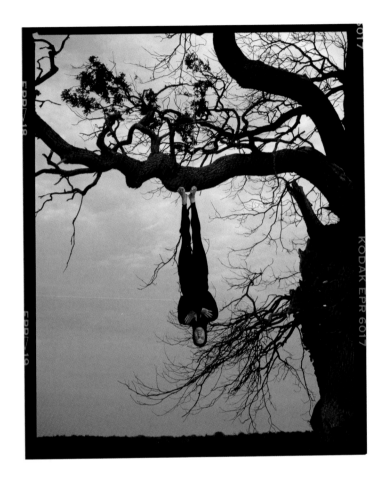

John Cleese, London, 1990

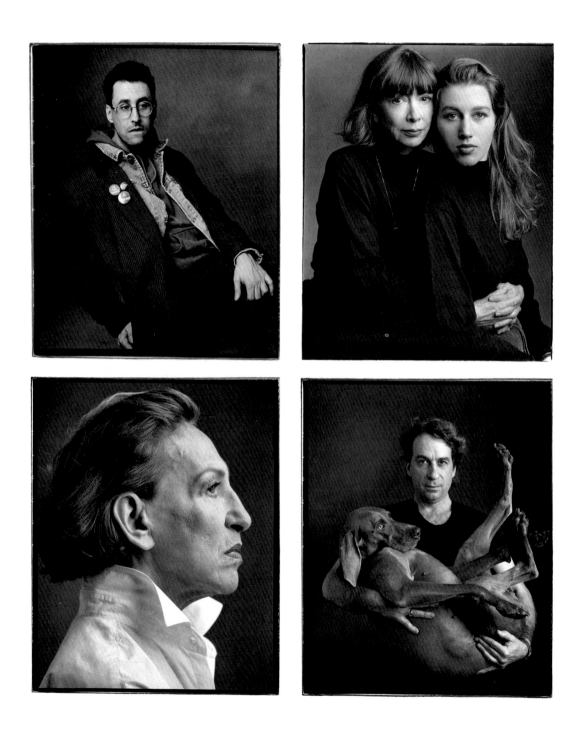

Tony Kushner, New York City, 1992. Joan Didion and Quintana Roo Dunne, New York City, 1989
Andrée Putman, New York City, 1989. William Wegman and Fay Ray, New York City, 1988

imagined they would be. Attempting to follow a client's directions altered my point of view. It just felt wrong.

Tina Brown took over as editor of *Vanity Fair* in 1984 and really put me to work, so I didn't need other jobs to fill up my time, but late in 1986 an art director from Ogilvy and Mather, Parry Merkley, asked me to shoot a new campaign he was developing for American Express. He said this campaign was going to be different. It was a portrait campaign and I would have the freedom to do what I wanted to do. I told him that was hard to believe, but he was persistent. Ogilvy and Mather wanted pictures of famous people and very little copy. Just the subject's name and the line "Cardmember since 19__" and the words "Membership has its privileges." The simplicity of it appealed to me. We put in writing as part of our deal that no one except Parry Merkley could be on the set. No one from American Express and no one else from the agency.

Parry asked me how much time I needed with the subjects, so that they would know what was required. It was the first time I had thought about that. How much time *did* I need to make a portrait? I came up with the formula of at least two days to work with a subject, in addition to location scouting. A day for meeting them and a second day for shooting or finishing any shooting that had started the day before. When you first meet someone you're just trying to be nice and picking up clues for a picture. You get ideas when you're with them that you wouldn't get simply by reading about them or studying their work. The two-day system provided for a reconnaissance mission, the first day, when I might take a few pictures or I might not. The first day gave me room to observe and talk. Then I could go away and think about what I'd learned. It's not as if we were taking photographs for two full days. The shoot itself could be very quick. In fact, as I refined the system over the years, I realized that I usually needed only two half days. People, understandably, often don't want to commit to two full days, and the point was only to have two separate sessions to work in. I now sometimes reserve the second day as a backup, but I don't necessarily use it.

The subjects for the American Express ads were chosen simply by making a list of the top people in a field. Parry would ask them if they wanted to

Evander Holyfield, New York City, 1992

participate, and they usually said yes. The only requirement the agency had for the photographs was that they be vertical and fill a page. They would sometimes appear on their own page, with type on the opposite page, or they would share a page with type.

It's hard for me to frame subjects in a vertical format. It doesn't seem natural. The eye sees horizontally. My early photographs were taken with a 35mm lens, which pretty much takes in a whole scene. When you aim a 35mm lens at someone's head it takes in a little bit of what is to the left and a little bit of what is to the right. The horizontal image produced by the 35mm lens is good for telling a story. A vertical image by its nature is going to be a more formal photograph.

The American Express shoots were more elaborate productions than I'd been involved with before, with much larger budgets. The magazines were pretty tight with money, but American Express was a different beast. Suddenly I was spending money like I'd never spent money before. I would fly to Detroit to shoot Elmore Leonard, and it would be snowing, and I'd say, "You know what, I don't really want to shoot here today. Let's go to Florida." And we'd go to Florida. You don't do that on a magazine budget. It was great. Money affected my relationships with the subjects also. They were being paid, and they were very cooperative. Collegial even. They wanted to do a good job.

The first sitting was with Tip O'Neill, who had just retired as Speaker of the House. Parry Merkley wanted to convey the idea that the viewer was getting an intimate, privileged view of the subjects, and we shot O'Neill sitting on a beach chair in the sand, in bare feet, with his pants legs rolled up. He was disheveled and there was a cigar stub stuck in the sand next to him. He gazed to the side—actually, at two women who were walking by. My problem with the photograph was that it didn't look natural. It was overlit. An intense strobe is good for a very graphic image, which this image was not. We shot O'Neill in bright sunlight and the strobe had to be intensified to be brighter than the sun. It started looking like Christmas.

The photograph of Willie Shoemaker and Wilt Chamberlain was taken on the beach at Malibu. The sky was bright, but I set the f/stop down so that

the scene looked darker than it really was. The picture worked because it was shot very formally. We were outside but the setup was like something you would do in a studio. I was thinking of circus pictures—Tom Thumb with the giant.

The John Cleese picture is something he and I came up with when we met at his house in London. My first idea was to photograph him in women's clothes, and he said fine. It's a tradition for English comedians to dress in drag. The stylist, Lori Goldstein, ran around London looking for over-sized high heels. But then John mentioned that he imagined himself hanging upside down from a goalpost like a big bird. I thought that hanging upside down from a tree like a bat would be more interesting, and the next day we were looking for the right tree, which turned out to be harder than we thought. There had been a huge storm in London and a lot of trees had blown down. The tree we decided to use was dead. It had a great silhouette because it didn't have leaves. Since John couldn't really hang from the limb I wanted to photograph—his weight would have brought it down—I hired a sixty-foot crane and hauled him into position. John couldn't stay up there very long because the harness was pressing against his rib cage. He wasn't getting any air. He turned red and started to pass out. We brought him down and then had him go up one more time.

Between 1987 and 1992 I shot a hundred and three portraits for that first American Express campaign. It was extremely successful and won several awards. The pictures had been allowed to tell a story with very little type on them. I learned so much on that campaign. It was a great way to experiment and explore ideas. American Express gave me a larger canvas to work on than I had ever had before. And there was a personal benefit. I didn't have a very good credit rating after all those years at *Rolling Stone*. I had applied for an American Express card and been rejected several times. I operated with cash. The agency found out about this when I left several thousand dollars in an envelope in a phone booth while I was on a shoot. Strings were pulled and I finally got my card.

The Gap campaign ran about the same time that the American Express campaign did. The Gap pictures were all black-and-white studio portraits.

Ella Fitzgerald, Beverly Hills, 1988

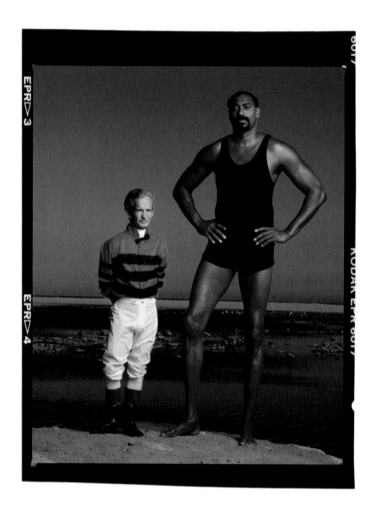

Willie Shoemaker and Wilt Chamberlain, Malibu, California, 1987

That was the basis of the campaign at first. I shot them in my studio on Vandam Street, which was in an old industrial building with glass windows lining the exterior walls, and in Los Angeles.

I had never thought of myself as a studio portrait photographer. I can be graphic, and the Gap photographs are graphic, but in a studio I had to rely on the subjects' ability to project themselves. When I began the Gap campaign I hadn't yet developed a method of establishing a relationship with a subject. I thought you just looked. I didn't know that you can control a situation by the way you talk to someone. You can draw them out.

An environment is important for my pictures. I like placing the subject somewhere. My first choice is the subject's own environment, but if that isn't possible I will set a stage for them. I would use a backdrop if the weather turned bad and I couldn't shoot outside, but I never felt they were going to be the best pictures. The Gap campaign forced me to work consistently with backdrops and to learn how to use them. I didn't use a white backdrop. With a white backdrop there's nothing to hold on to in the photograph but the subject and the graphics. Avedon owned the white backdrop. Irving Penn's gray backdrop was more appealing to me, although it turns out that Penn's backdrops weren't really gray. He shot in black and white and the light fell off white backgrounds, making them look gray. I've borrowed that look and made gray mine. It's my white.

I still think of my work in the studio as very straightforward and direct. And I'm still not totally comfortable with it. But every so often I see someone with whom I'd like to do that sort of picture. It's so simple. It's a nice tool to have. A nice style to have in your back pocket.

AL SHARPTON

The Reverend Al Sharpton is not unfamiliar with show business. He started preaching in a Pentecostal church when he was four years old. In the sixties, he performed with Mahalia Jackson on the gospel-music circuit. Later, he was James Brown's tour manager. When Ronald Reagan asked Brown to the White House on Martin Luther King's birthday, Brown took Sharpton along, but first he took him to his hairdresser. Sharpton has worn a processed hairstyle like James Brown's ever since. He says it symbolizes their bond.

When Tina Brown asked me to take Sharpton's picture for *Vanity Fair,* he was well known as a flamboyant and controversial activist and community organizer. We had arranged to meet at a church in Harlem, but Sharpton sent word that he was going to be an hour late. I asked why and was told he was having his hair done. I said I would meet him at the salon. We didn't talk about taking pictures there until I arrived and saw him in the chair in curlers. His hair was still being worked on when I left to go to the church where the formal sitting was to take place. The next day, a picture similar to the one I had taken in the salon appeared on the front page of the *New York Post.* Their photographer had found out where we were and had come by after I left. That was annoying. Monthly magazines can't compete with the dailies.

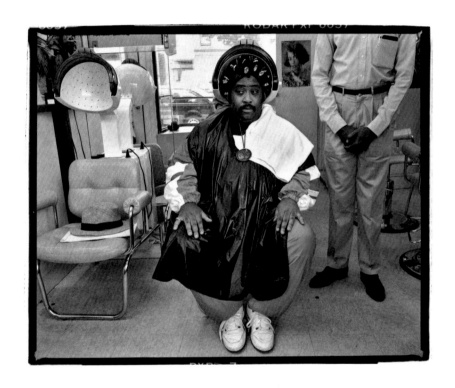

The Reverend Al Sharpton, PrimaDonna Beauty Care Center,
Brooklyn, New York, 1988

ARNOLD SCHWARZENEGGER

The portraits of Arnold Schwarzenegger represent a long collaboration. We first worked together in 1975, when he was competing in the Mr. Olympia body-building contest in South Africa. Arnold was twenty-eight. He'd already been Mr. Olympia five times and he was about to retire from body building. He wanted to get into films. The 1975 Mr. Olympia contest was the basis for George Butler's documentary *Pumping Iron,* the movie that popularized body building and introduced Arnold to a wider audience. Butler was a friend of Jann Wenner's. I don't remember exactly, but I assume that my trip to South Africa was what is now known as a press junket. I can't imagine that *Rolling Stone* would have paid for it. I do remember that Butler was always filming when I was trying to work.

Arnold is the center of *Pumping Iron* in every way. In terms of the narrative of the preparation for the contest, he is the guy everybody else has to beat, which they pretty much know they can't. As a character, he is aggressively, if charmingly, self-confident. Witty. Intelligent. Full of himself. He somehow makes what is a rather freakish scene seem almost normal, although it never seemed normal to me. Steroids were legal then. I had just spent several weeks on tour with the Rolling Stones, where Mick Jagger was the male sexual ideal. Being around all those super pumped-up guys made

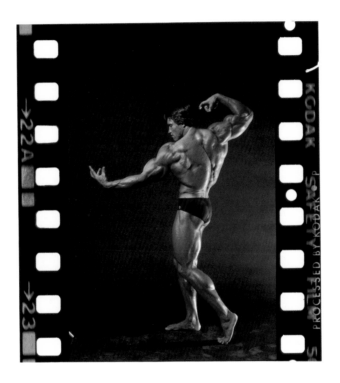

Arnold Schwarzenegger, Pretoria, South Africa, 1975

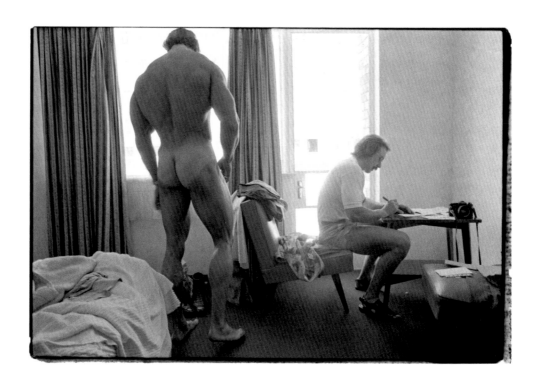

Arnold Schwarzenegger, Pretoria, South Africa, 1975

me feel like Diane Arbus. It didn't help that we were in South Africa, which still had apartheid. There were separate bathrooms for blacks and whites. It was an uncomfortable situation.

Arnold was central to the situation and at the same time somehow aloof from it. He was very shrewd about the competition. The photograph in the hotel room was taken the morning after he won. He was sharing a room with his friend Franco Columbu, who came in second in the final pose down. Arnold and Franco were very competitive and brotherly and I decided that I wanted to photograph them in bed. I had in mind something that was, in retrospect, along the lines of Bruce Weber. The magazine used one of the photographs of them horsing around. Standing on their heads on their pillows. It was more silly than erotic. They had their underpants on for that shot, but Arnold was also walking around naked that morning. Like most models or athletes who love their bodies, Arnold didn't mind being naked.

Two years later, when I had to photograph Dolly Parton and needed an interesting background, I asked Arnold to pose with her. She was a much bigger star than he was. Most people had never heard of him then. I was thinking of chopping off his head in the frame, but it became a moot point because Dolly kept standing in front of him. In the portrait all you can see of him are his flexed arms and legs. He's furniture.

Arnold told the *Pumping Iron* filmmakers that "I got the feeling that I was meant to be more than just an average guy running around, that I was chosen to do something special. I was always dreaming about very powerful people, dictators and things like that. Or some savior, like Jesus." Ten years later he was the Terminator. I shot him for the *Vanity Fair* Hall of Fame in 1988. We were shooting on the beach and he said he had a horse, and I said well, bring it along, not thinking much about it. I couldn't believe it when the horse showed up. It looked like Arnold. Arnold's thigh in those white pants looks like the horse's thigh. It was not a picture that I liked right away, because it is primarily about form and I'm reluctant to have form impose the meaning on a picture. But in Arnold's case form is also content. I had just begun to do the black-and-white Gap advertising campaign then and was working in that style.

By the end of the nineties, Arnold was a successful businessman and was becoming a political figure. He had served as chairman of the President's Council on Physical Fitness and Sports under the first George Bush. When I photographed him in Sun Valley, where he has a house, he was very sentimental and nostalgic. He kept reminding me of the things we had done together in the past. Mortality was looming, I think. He was about to have a major heart operation. They were going to put in an artificial aortic valve.

Arnold was just about to turn fifty and his body had changed. He had trimmed down and lost weight. When we went up on the mountain for the shoot he didn't want to take his shirt off. He said it was because it was freezing up there, which it was, but I think it was because he had decided not to rely on his body to sell himself. Actors who use their bodies in movies are accustomed to being asked to take their shirts off. With most people, you don't bring this up before the shoot, because they will say no, but actors whose bodies are part of their professional persona like to be warned. I learned this from Sylvester Stallone. I asked him to take his shirt off in the middle of a shoot and he explained that if I had mentioned it earlier he would have waxed his body and done whatever else it is they do to prepare. When Arnold was standing there in just his T-shirt, he flexed his muscles and posed a bit, but I chose a picture of him with his muscles at ease. I thought he looked more modern and less contrived that way.

The picture brings Leni Riefenstahl to mind. Arnold is Austrian. His career was built on willpower. It's a heroic pose, redolent of German Romanticism. But the biggest influence for the picture was Sun Valley ski photos. A lot of what happens in a shooting is based on what is available. Sun Valley was developed as a ski resort by Averell Harriman, the chairman of the board of the Union Pacific Railroad, in the 1930s. The Union Pacific tracks ran through the northern part of the United States, and Harriman was looking for a way to make the trip more attractive to passengers during the winter. Alpine skiing was a little known sport in the U.S. then, but Harriman had discovered European ski resorts when he was on business trips abroad. He asked a knowledgeable Austrian count to explore the American West and propose a spot that could be developed along the lines of St. Moritz

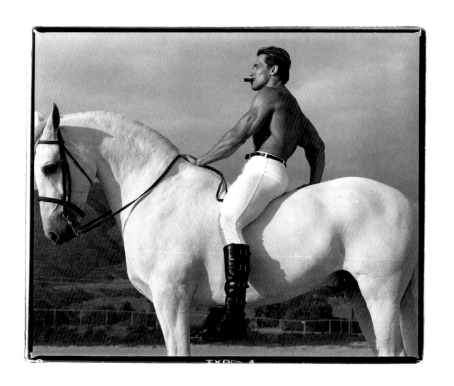

Arnold Schwarzenegger, Malibu, California, 1988

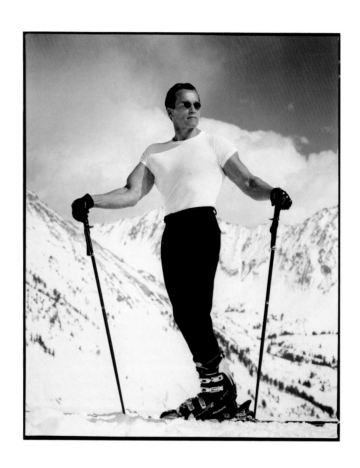

Arnold Schwarzenegger, Sun Valley, Idaho, 1997

or Kitzbühel. The count suggested a remote sheep-herding area of Idaho and somebody decided to call it Sun Valley. Union Pacific transformed the area with Tyrolean architecture, invented chair lifts, and imported Austrian ski instructors and musicians in Bavarian costumes. The first guests were Astors and Whitneys and Rockefellers and a large contingent from Holly-wood. The lobby of the Sun Valley Lodge is filled with photographs of movie stars on the slopes. Gary Cooper, Clark Gable, Ingrid Bergman, Errol Flynn. I looked at them over and over when I was there.

Arnold talked about this shoot later as an extreme experience, although I think he just liked to tell the story in an amusing way. There was a blizzard and we had a tiny window in the storm to take a helicopter up to the top of the mountain. Arnold was leaving Sun Valley the next day and we weren't going to have another chance. The stylist, Lori Goldstein, wouldn't go up with us. She thought we were crazy. I shot the picture from the ground, on my stomach in the snow. I was about as low as I could go without digging a ditch to shoot from, like Riefenstahl did for the 1936 Olympics.

DANCE

My mother was a dancer. Some of my most vivid childhood memories are of her dancing on the beach, striking poses. Years later, I photographed her that way. So my interest in dance precedes my interest in photography, although I remember seeing Barbara Morgan's photographs of Martha Graham when I was young, especially the famous ones of Graham kicking her leg out under that long, full skirt she wore in *Letter to the World*. When I became aware of who Barbara Morgan was I began looking more closely at those pictures and trying to understand how they were made. Morgan and Graham worked together in the thirties and forties and were friends for sixty years. They created the photographs together in a studio—not in performance. The pictures were stagings of the actual dance.

I was very enamored of the relationship Morgan had with Graham, and in the summer of 1990, when Mikhail Baryshnikov asked me to spend a couple of days in northern Florida taking pictures of a new company he was forming with the choreographer Mark Morris, I said yes. Can I come for three or four weeks? Can I come longer? I wanted to get involved with the making of a dance. I wanted to spend time with the dancers and with Mark and Misha, both of whom I had gotten to know a few years earlier. I had photographed them for *Vanity Fair* and had shot the pictures for

Mikhail Baryshnikov, New York City, 1989

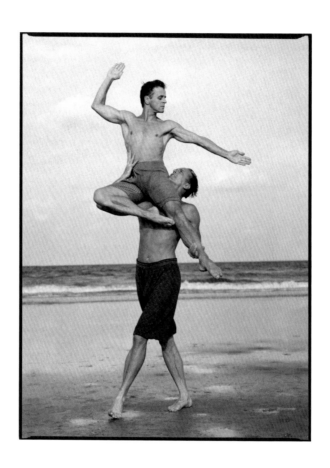

Mikhail Baryshnikov and Rob Besserer, Cumberland Island, Georgia, 1990

the fiftieth anniversary program for American Ballet Theatre when Misha was the company's director. The photographs of Misha for the magazine were of him as a glamorous man more than as a dancer, and I had made a double portrait of Mark and Misha in suits when Mark choreographed a piece for ABT. But I had also photographed Mark dancing the role of Dido in his *Dido and Aeneas* and I knew them both best as dancers.

The new company—which was made up of eight dancers, including Misha, who were distinguished in their own right and older than the dancers in most other companies—was working in studios that had been set up at the White Oak Plantation, a 7,500-acre wildlife preserve owned by the Gilman Paper Company. The company's chairman, Howard Gilman, was a great patron of the arts and one of Misha's closest friends. Misha had lived in Howard's apartment in New York after he defected to the United States in 1974. White Oak was a peaceful and isolated place to work. Everyone was taken care of and there was a wonderful sense of purpose.

I had brought a lot of books of dance photographs down to Florida with me, including some of Morgan's books on Graham, and we all talked about them. Rehearsals took place in a dance studio in the woods, so I constructed a portable photography studio for myself nearby. I took some reportage-type pictures of the rehearsals, but I found myself falling back on the portraits. I began to understand that dance can't be photographed. Or even filmed, for that matter. It is an art that lives in the air. Morgan and Graham had figured this out long before me. Morgan wrote that their intention was simply to capture "the most profound and most crucial moment."

All dancers are, by and large, a photographer's dream. They communicate with their bodies and they are trained to be completely responsive to a collaborative situation. Sometimes at White Oak, Misha would come dancing across the floor and I would be filled with wonder. I'd been taking him for granted. The piece they were working on when I was there is called *Motorcade*. It is set to the Saint-Saëns septet and is typical of Mark's choreography in that it is focused on the group more than on any individual or pair of dancers. Mark is the greatest choreographer of my time, certainly,

and there is a wonderful sense of freedom in his work. Men partner men, women partner women, the music can be anything from baroque opera to hillbilly songs. In *Motorcade,* Rob Besserer picks Misha up in the wings and runs across the stage with him. I photographed that moment one morning on Cumberland Island, a lush barrier island off the southern coast of Georgia, not far from White Oak. We had gone there to take a look and decided that it would provide a good setting for portraits.

The idea for the "Rousseau" portrait of Mark came about when I walked into the communal living room at White Oak one afternoon and found him resting on a couch. He looked so elegant. Mark has a very powerful physical presence. He radiates self-confidence. The photograph is a result of observing him closely over several weeks. It wouldn't have happened if I'd gone to Florida for a day or so and left. At White Oak, I had the luxury of letting things develop in a slow way rather than spending ten minutes, or, if I'm lucky, two days, on a normal magazine assignment.

The White Oak photographs were shot in black and white in natural light. We worked on portraits in the little portable studio in the morning and then again later in the day. When I was using film I was always afraid to shoot in color against a forest background. Green can very easily read as black if light isn't directly on it. Now, of course, with digital, you can open up the green. There's more latitude with digital color. If I were shooting at White Oak now I'd probably try some color.

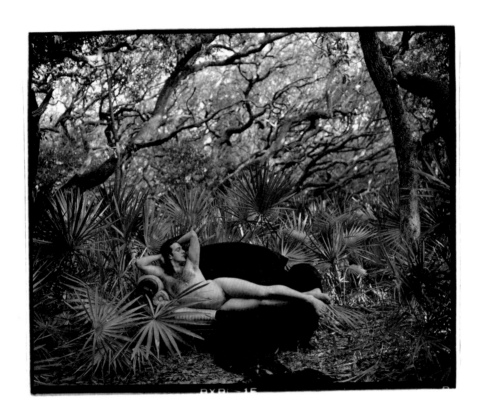

Mark Morris, Cumberland Island, Georgia, 1990

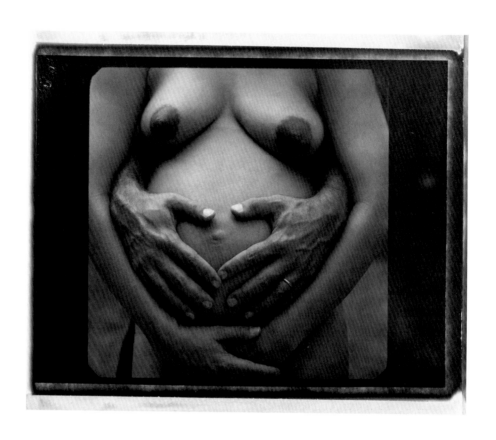

Bruce Willis and Demi Moore, Paducah, Kentucky, 1988

DEMI MOORE

It's hard to imagine now, but the portrait of Demi Moore nude and pregnant on the cover of *Vanity Fair* was truly scandalous in 1991. Scandalous in the sense of shocking and morally offensive to some people. The first day the issue was available, it sold out on newsstands at Grand Central Station during the morning rush hour. Newsstands in other parts of the country displayed it in a white paper wrapper, as if it were a porn magazine. Several supermarket chains refused to sell it even with the wrapper. Editorialists and pundits weighed in. A few years later, the picture was held responsible for the rise of body-hugging maternity fashions.

None of this was my intention, although it's gratifying to think that the picture helped make pregnant women feel less awkward or embarrassed about their bodies. It began as a shoot with a specific problem. Demi had a new movie coming out and Tina Brown wanted to put her on the cover, but Demi was seven months pregnant with her second child. Tina and I talked about how to handle this and we decided to go for a glamorous, sexy look. Lori Goldstein, the stylist, brought diamond earrings and a thirty-carat diamond ring to the studio in Los Angeles where we were shooting. We had long gowns, including a green satin robe by Isaac Mizrahi.

Demi and I had worked together several times before, and I'd taken her

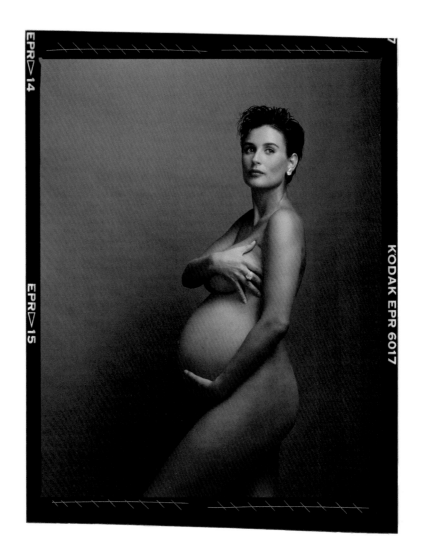

Demi Moore, Culver City, California, 1991

wedding pictures when she married Bruce Willis, in 1987. I had said to her then that I was interested in photographing a pregnant woman, which at that point I never had. Demi called me when she was going to have their first child. Bruce was working on location in Kentucky and she had gone there to have the baby. I stopped off in Kentucky on the way back to New York from Los Angeles and took a few rolls of black-and-white film. Just for them. Demi and Bruce were not shy about documenting the pregnancy. Several friends and a man with three video cameras were in the room when their daughter was born a few weeks later.

At the cover sitting in 1991, I shot a few close-ups and some full-length portraits. Demi was by no means camouflaged for any of them. In the standing portrait published inside the magazine the green satin robe is pulled off her shoulders and it falls open to expose her belly and leg. In another picture she's wearing a black lace bra and panties. But the fully nude picture was not taken until toward the end of the shoot and was intended just for Demi. I was taking some companion photographs to the ones I had made during Demi's first pregnancy. As I was shooting, I said, "You know, this would be a great cover." It wasn't until I got back to New York and looked at the proofs that I realized that there really was a great cover photograph there. Tina agreed, although she thought that Demi would be furious if we ran it. She was surprised when Demi said yes right away. We all knew what we were doing up to a point, but none of us completely understood the ramifications.

A few months after the Demi Moore picture was published, an exhibition of my work from 1970 to 1990 opened at the International Center of Photography in New York. The director of the center, Cornell Capa, wanted to blow the picture up and hang it in the stairwell. I wouldn't let him. It was a popular picture, and it broke ground, but I don't think it's a good photograph per se. It's a magazine cover. If it were a great portrait, she wouldn't be covering her breasts. She wouldn't necessarily be looking at the camera. There are different criteria for magazine covers. They're simple. The addition of type doesn't destroy them. Sometimes they even need type. My best photographs are inside the magazine.

PERFORMANCE

When I made a series of portraits of performance artists for *Vanity Fair,* I was working with people who have very strong visual concepts that are central to their work. This didn't make things easier. Performers don't usually want to re-create what they do onstage for a photo session. They save it for themselves.

Cindy Sherman had not been photographed as herself very often. She was something of a mystery personally. She was most well known for her "Untitled Film Stills," a series of black-and-white photographs she made in the late seventies. They were portraits, and she was the only subject, but they were not self-portraits. She had disguised herself as actresses in generic B-movie roles. In another series of portraits, which had been completed a couple of years before I took her picture, she cast herself as characters in famous paintings.

I was nervous about photographing Cindy because I admired her so much. When I went to meet her at her loft to talk about the portrait, she came to the door dressed in a white shirt and black pants. I asked her if she had any ideas about how she wanted me to take the picture, and she said that she would like to be hidden. I thought she could hide if there were multiple Cindy Shermans, and she liked that idea. It was the first time I

Cindy Sherman, New York City, 1992

had hired a casting agent for a picture. The agent tried to find look-alikes. Young actresses who were willing to cut their hair. I wanted to photograph all of them in the same outfit Cindy was wearing when she met me, but it turned out that the simple white shirt was from Agnes B and the pants were by some Italian designer and the shoes were Manolo Blahnik. It would have cost too much to dress everyone like that, so we went to the Gap for the pants and shirts.

The shoot with the Australian performance artist Leigh Bowery was a battle of wills. I was enamored of the big Lucian Freud portraits of Bowery naked and I wanted to see flesh, which is what the Freud paintings are about, but Bowery—unlike most of the other performance artists— wanted to be photographed in the paraphernalia from his stage work. He had designed and made fetishistic outfits that he wore for his late-night shows in out-of-the-way clubs in London and New York. He presented himself to me as the absolute opposite of the figure in the Freud portraits. I was furious at the time, but I realize that he was not really hidden in that costume. He was very present even though he was covered up with black rubber.

Bowery did eventually strip down. He took off the rubber outfit and I photographed him and his assistant and companion, Nicola Bateman, in a tableau in which he seems to be giving birth to her. But, again, it was literally a part of their club show. I realized that in Bowery's work with Lucian Freud, he was an object. The paintings were Freud's idea of Bowery. In the sitting with me he wanted to express himself.

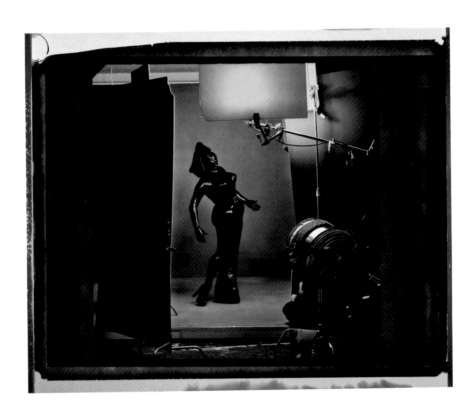

Leigh Bowery, New York City, 1993

Carl Lewis, Pearland, Texas, 1996

PEAK PERFORMANCE

Athletes are proud of their bodies. They've worked very hard on them. Photographing athletes is a little like photographing dancers, or at least it seems that way to me, perhaps because I've had more experience with dancers. Dancers and athletes use their bodies in performance, they don't mind posing, they are comfortable in front of the camera.

I almost didn't go down to Texas to photograph Carl Lewis when he was training for the Olympics in 1996. I had been working for two and a half years on a portfolio of portraits for the Atlanta Committee for the Olympic Games and the pictures I had taken had been made into a book that was about to go to press. It had to be printed in time for the opening ceremony, which was only weeks away. I didn't know whether I had time to include Lewis, and there was a good chance that his participation in the games wouldn't be that significant anyway. He was a huge star, but he was much older—thirty-five—than most of the other athletes who would compete in the Olympics. He hadn't been dominant in sprinting and long-jumping, his specialties, for a long time.

When I got to Texas, I was astounded by the state Lewis's body was in. It was like a piece of sculpture. I had photographed him before, but I'd never seen him when he was so close to competing. His body was fine-

Charles Austin, Atlanta, Georgia, 1996

tuned to a point that would be impossible to sustain for very long. It wasn't just that his body was strong and beautiful. He had reached a mental and emotional place that you knew he would never reach again. A few weeks later Carl Lewis won the gold medal in the long jump. It was a stunning, brilliant performance. He retired the following year with nine Olympic gold medals. Only three other athletes in the history of the games had earned that many.

The photographs for the Olympics project were taken while the athletes were training and qualifying for the games. I worked with Polaroid negatives most of the time so that if the picture involved movement I could see right away whether I had it. Figuring out how to capture the right slice of time takes a little practice. I had learned this when I photographed the hurdler Edwin Moses when he was preparing for the 1984 Olympics. Moses was one of the greatest track and field athletes in history. A hurdle had been set up on a track and I was lying next to it on my stomach with a camera with a Polaroid back. Moses ran down the track and jumped and I clicked the shutter. When I pulled the Polaroid out, there was just a picture of the hurdle, but no Moses. That was embarrassing. I thought I had clicked the shutter pretty fast. I said, Let's do it again. So Moses ran down the track again and jumped and this time I got his foot. The bottom line is that if you see the picture through the viewfinder, you're too late. You're not going to get it on film. Sports photographers know how to compensate for this. Their intuition and timing are impeccable.

In 1996, I photographed American athletes training in every Olympics event. I didn't photograph the games themselves because I realized that I could never get as close to the athletes as I was during the training sessions. Charles Austin wasn't expected to win in the high jump. Cuban athletes dominated that event, but the Cuban who held the world record was injured at the Olympics and Austin unexpectedly won the gold medal and set an Olympic and American record.

WAR

In 1990, when I was preparing the first major retrospective of my photographs, I went through thousands of pictures and discovered that the early reportage meant the most to me. I longed to go out into the world again with a little 35mm camera and look for a story. My earliest 35mm pictures were taken when I was visiting my family at Clark Air Base in the Philippines, in 1968, in the middle of the Vietnam War. Soldiers badly wounded in Vietnam were sent to Clark to be treated before they were shipped home. I had grown up around soldiers and I felt at ease taking their pictures, although there was certainly a lot of strain in terms of my feelings about the war by then. I didn't photograph a military operation in an official capacity until many years later. In 1982 I covered the Israeli invasion of southern Lebanon for *Rolling Stone*. A writer and I traveled through the war zone into Beirut. We were with the Israeli army most of the time. One of my most vivid memories of the trip is of watching some wire service photographers rearrange a scene at an observation post in an abandoned villa in the hills overlooking the city. It was a slow day in terms of fighting, and they were moving the rifles around to make a better picture. That confused and shocked me.

I was developing my own style of setting up formal portraits and theatrical scenes around this time, but I didn't consider those conceptual portraits to

Sarajevo, 1993

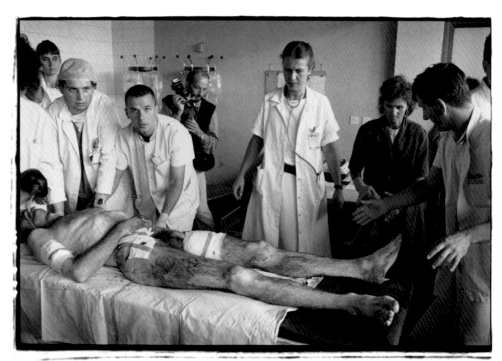

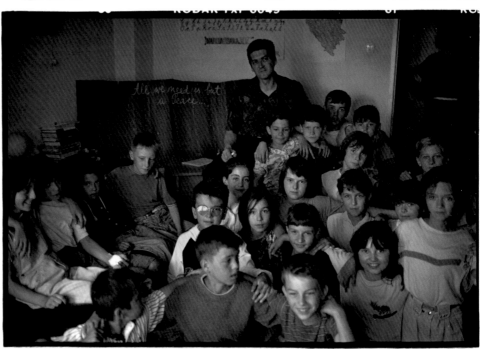

Dr. Sanja Besarović, Koševo Hospital, Sarajevo, 1993

Classroom, Sarajevo, 1993

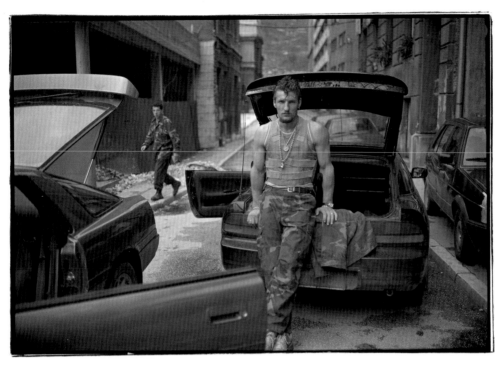

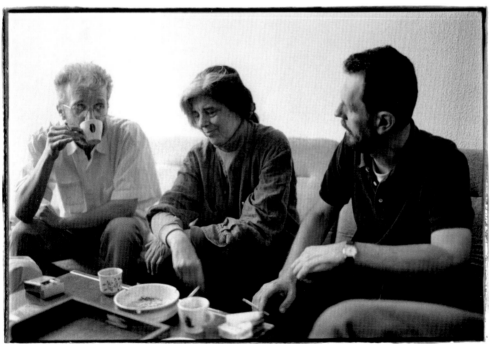

Ćelo, Bosnian army commander, Sarajevo, 1993

Haris Pašović, Susan Sontag, and Zdravko Grebo, Sarajevo, 1993

be journalism. Portrait photography was liberating. I felt free to play within the genre. Photojournalism—reportage—was about being an observer. About seeing what was happening in front of you and photographing it. You didn't tamper with it. For my generation of photographers the rules were very clear. That's why so much is still written about whether Robert Capa did or did not stage the picture of the falling soldier during the Spanish Civil War and why Roger Fenton moved the cannonballs for the picture of the battlefield in the Valley of the Shadow of Death during the Crimean War. What they did matters.

In 1993, Susan Sontag was in Sarajevo, working with a group of actors during the siege of the city by the Serbs. She was there because she was incensed by the refusal of Western governments to intervene in what had turned into a bloody massacre of a large civilian population. She wanted to show her solidarity with the people there. To bear witness. I was inspired by her example and was also looking for a way to go someplace by myself, with no assistants, and work very simply, the way I did when I was young. I had met some photographers who were working in Sarajevo, and they all said that I should go there, but I didn't know how to approach the subject. I hadn't been working as a war photographer and they had. I didn't want to be a day-tripper. Then one of the photographers, Gary Knight, with whom I had become friends, said, "Why don't you go and do a set of portraits?" Gary clarified things for me. He said he would help me and he gave me a way to get started. *Vanity Fair* agreed to publish something, which gave me credentials.

Sarajevo had been blockaded and besieged for over a year by the time I went, in the summer of 1993. There was no electricity and no running water. Food and medicine were scarce. The city is at the bottom of a bowl created by a ring of mountains, and the Serbs sat in the mountains lobbing shells down. Snipers were picking people off at random. The UN was sending in airlifts of supplies, although not a lot. I went in on one of the UN planes. You could bring only what you could carry, which meant a bulletproof vest and a backpack full of clothes, cameras, batteries, and film. I took a Contax with a small variety of lenses and a Fuji 6x9 with a fixed lens. I chose those

cameras primarily because they didn't rely on batteries. I wanted cameras with minimal dependence on electronics. I carried a small on-camera strobe with me, but I quickly began to appreciate working in natural light. Since there was no electricity, light didn't come from every direction. A room was lit from the light coming through the windows. You saw the world the way the Renaissance saw it, and it was hauntingly beautiful.

I had discussed my plans with Susan and others before I went, and I had a list of people I wanted to photograph. The journalists who had been in the city for a while added to it. All the journalists were staying in one place, the Holiday Inn, and since we saw one another every day we exchanged ideas. The first thing that everybody new in town was told to do was visit the morgue at the hospital, so that you could understand what was going on. There were dead children, and young mothers. People from all walks of life. Death was random. The sound of gunfire and shelling went on all day. Shipping containers had been placed around the streets so that people could walk behind them. You didn't go out at night, of course.

Jeffrey Smith of Contact Press Images had helped me get in touch with someone who rented armored cars to news organizations. That's how I met Hasan Gluhić. Hasan was my driver and guide. He got me everywhere. Hasan was with me the day I went to the apartment of a woman who had just won a beauty pageant. She had been crowned Miss Besieged Sarajevo. There was some irony intended, I think. Miss Besieged Sarajevo lived in a high-rise development on the western edge of the city where there was a lot of shelling. A mortar came down in front of our car as we drove through her neighborhood. It hit a teenage boy on a bike and ripped a big hole in his back. We put him in the car and rushed him to the hospital, but he died on the way. Two other people were killed in the blast, including an old woman who had been sitting outside her house in the sun.

Between 300,000 and 400,000 people still lived in Sarajevo when I was there. Since people were killed every day, there were makeshift cemeteries all over the city. One of the biggest ones was in a soccer field on the site of the sports complex built for the 1984 Winter Olympics. It seemed extraordinary to me, but in the midst of all this carnage and misery, people tried to keep

Nedžad Ibrišimović and his grandson, Sarajevo, 1993

Hasan Gluhić, Sarajevo, 1993

Soccer field, Sarajevo, 1993

Kemal Kurspahić, Gordana Knežević, and Zlatko Dizdarević, Sarajevo, 1993

doing, as best as possible, what they had done in their lives before the siege. Sarajevo had been a flourishing, cosmopolitan city with a rich cultural life. A schoolteacher still held classes, only now in his eighth-floor walk-up rather than in the school, which had been demolished. Zdravko Grebo, a former law professor, represented the Soros Foundation in Sarajevo and ran a radio station. Haris Pašović, who returned to Sarajevo from safety in Europe, put on plays in a theater lit with candles. Nedžad Ibrišimović fought on the front line, which was in his neighborhood, and continued to write novels. Kemal Kurspahić, Zlatko Dizdarević, and Gordana Knežević, editors of the independent daily newspaper *Oslobodjenje,* managed to publish an edition every day from their underground office. One of the bravest, most noble people in Sarajevo was a Serb surgeon, Sanja Besarović, who stayed in the city and continued to work in the hospital even though the conditions there were abysmal. There was often no anaesthesia, and the hospital was frequently the target of shelling. I came in one day and found her treating a man who died on the table as I was photographing him.

The concerns I had before I went to Sarajevo about what kinds of pictures I would take were erased simply by being there. There wasn't time to worry about whether I was taking a portrait or some other kind of picture. Things happened too fast. You could only respond to them.

I went to Sarajevo again early in 1994, and that summer I traveled to Rwanda, where, over the course of a hundred days, a million people had been murdered. Hutu militias wielding machetes, clubs, and guns had massacred Tutsi civilians while the rest of the world refused to acknowledge the genocide and intervene to stop it. Some of the worst attacks took place in churches and mission compounds where terrified people had sought refuge. The violence had finally ended a month before I arrived. There was nothing to do but record the evidence.

Blood on a mission-school wall, Rwanda, 1994

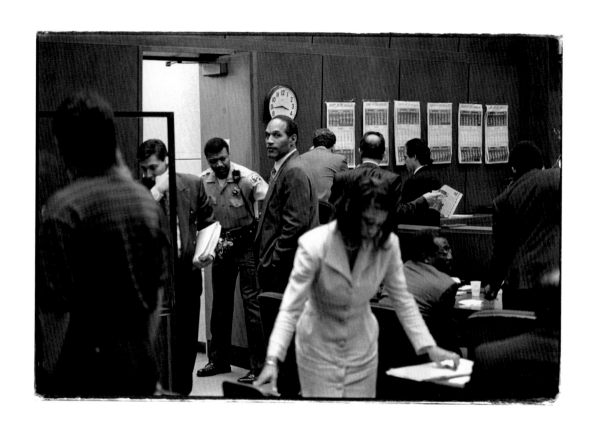

O. J. Simpson, Los Angeles Criminal Courts Building, 1995

O. J. SIMPSON

Being well known can work against a photographer. If you're recognizable, if people are curious about what you're working on, it is pretty much impossible to just watch a story unfold. You're too visible. You become part of the story. But then there are times when being well known opens doors that would otherwise be shut. One of the most flagrant examples of special access for me was the O. J. Simpson murder trial. I used to joke—because I was embarrassed about it—that I was born to cover that trial.

The Simpson case was a media sensation from the moment Nicole Simpson and Ron Goldman were stabbed to death in front of Nicole's condo in Brentwood. When O.J. tried to leave town in the white Ford Bronco, the police chase was covered live by news helicopters. The whole country became obsessed with the story. Court TV broadcast the trial, which lasted ten months, in its entirety. It was the first big reality show. I remember watching it and thinking how glad I was that I didn't have to shoot it. And then Tina Brown called and told me she wanted me to go to Los Angeles and cover it for *The New Yorker*.

Tina had become the editor of *The New Yorker* two years earlier. *The New Yorker* had a long history of distinguished reporting, but it had never published photographs before Tina arrived and began shaking things up.

The murder site, 875 South Bundy Drive, Brentwood, California, 1995

She hired Richard Avedon as the first staff photographer. I wanted very much to work for them—although I was committed to *Vanity Fair* in the long run—and I didn't think I could turn the O.J. assignment down.

Photographers covering the trial worked in a pool. You signed up for the pool and waited for your turn. Only four or five photographers were allowed in the courtroom at any one time. I signed up, but I was told I couldn't participate. I don't remember why, but whatever the reason, it was pretty annoying. I had learned by then that the judge in the trial, Lance Ito, was a fan of mine and wanted to meet me. The 1970–1990 exhibition of my work had just closed at the Los Angeles County Museum of Art and Judge Ito had seen it. So had the district attorney and a lot of other people involved in the trial. I went to the judge's chambers and talked to him about what I wanted to do and asked him to sit for a portrait. He very reluctantly declined to pose, but when I told him I couldn't get a seat in the courtroom he said, "Well, this is my courtroom and I can let in anyone I want to." I was given my own slot, outside of the pool system. Once I had access to the courthouse I was able to meet all the people who wouldn't answer their office phones. Like everything else in L.A., the whole system depended on who you knew. And they were flattered that I had come from New York and wanted to take their pictures.

I had photographed Robert Shapiro, the lead defense attorney, for *Vanity Fair* a few months earlier, and he was very helpful. He negotiated with O.J. for days about sitting for a portrait in jail, but O.J. was worried that he wouldn't have the right clothes. Then we were going to do a picture in a room behind the courtroom, but O.J. was worried about having handcuffs on. I loved that detail, of course. Finally Shapiro arranged for O.J. to turn around and look at me when he was walking out of court. That opportunity seemed to be falling through also, however, when O.J. realized that he was wearing a blue suit that day. I pointed out to Shapiro that it would be a black-and-white photograph, which calmed O.J. down. No one was supposed to take pictures in the few moments when everyone in the courtroom rises and files out, but I managed to get two or three frames. They reprimanded me but they didn't take the film away.

You're swimming in the sleaze when you work like this. That's how you get the picture. You can only hope that the edit will impose a larger meaning on the project. Tina ran a sixteen-page photo essay in *The New Yorker*. I was grateful, but I think that if I had been the editor I would have run a series of pictures that I took at the murder site. It was like being at Graceland. Traffic was backed up. Tourists were photographing one another in front of the gate. That would have been an interesting portfolio.

One of the things this job did for me was reinforce my belief in photography. You may think that you can't compete with the barrage of images on television, but individual pictures have their own impact. You can study them. They remain.

Los Angeles Criminal Courts Building, 1995

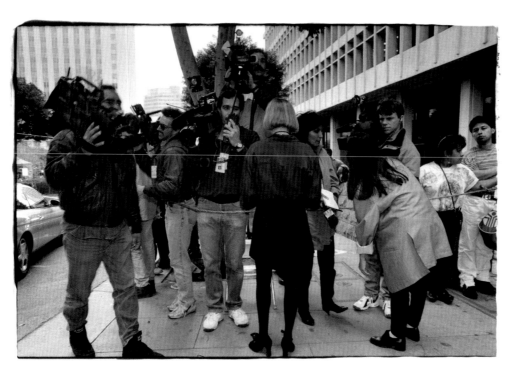

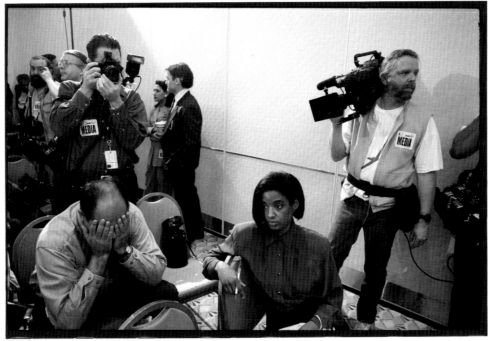

Tony Curtis and Jack Lemmon, Los Angeles, 1995

IMPROMPTU

For *Vanity Fair*'s first Hollywood issue, in 1995, I decided to photograph Tony Curtis and Jack Lemmon in drag as an homage to their roles in Billy Wilder's *Some Like It Hot*, which came out in 1959. Curtis and Lemmon gave arguably their greatest performances in *Some Like It Hot*. The American Film Institute calls it the best American comedy film of all time. Their portrayals of two jazz musicians disguised as women in an all-girl band are brilliant—nuanced, profound even. But as I watched them put on their makeup I realized that what was interesting was to see them in the middle of their transformation. To see the actor's mask.

PATTI SMITH

In 1978, Patti Smith's new album, *Easter,* and the single "Because the Night" were in the Top Twenty. It was Patti's first big commercial hit and she was going to be on the cover of *Rolling Stone*. I had gone on the road with her and the band for a while, photographing performances and doing some offstage reportage. When we got to New Orleans we decided to do the cover shoot there. An assistant came out from California—I was just starting to work with assistants then—and I told him that I wanted to photograph Patti in front of a huge wall of flame. I suppose I was thinking of the line "Desire is hunger is the fire I breathe" in "Because the Night."

The assistant said he knew what to do. We rented a warehouse and he strung up a net soaked in kerosene and Patti stood in front of the net and the assistant set fire to it. That lasted for about five seconds. The net burned up and fell on the floor. It was summer and 110 degrees inside the warehouse already, but we decided that the only way to get a flame to burn long enough was to set fire to the barrels of kerosene themselves. In those days you could do things like that. We didn't think about getting fire department permits or anything. The warehouse didn't burn down, miraculously, although Patti's back got a little singed.

Patti is sweating and her blouse is sticking to her skin because of the

Patti Smith, New Orleans, 1978

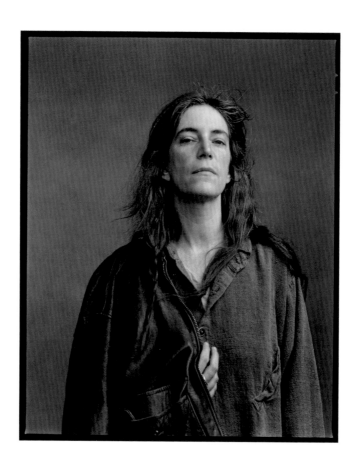

Patti Smith, New York City, 1996

intense heat. She is wearing her own clothes, and there was no stylist or hair-and-makeup person. Patti says that when she first saw the cover on the stands, she thought, "Is that what I look like?" She says she came to understand many years later that the person I had seen when I took the photograph was someone she wasn't consciously aware of then. That she grew into the person in the picture.

In 1996 Patti had just returned to New York after years of living quietly in a suburb of Detroit. Her husband had died after a long illness and her beloved brother had died suddenly a few weeks later. She was bereft, with two young children to care for. She was walking the street aimlessly, feeling depressed, and when she realized that she was near my studio, she called to ask if it was OK to come up. It felt natural to take her picture. She was wearing her husband's leather jacket and she seemed breathtakingly vulnerable—so raw, so open. Patti thinks that the picture shows an inner strength that the camera saw in 1978 but that she had to discover over time and through bitter experience. It was used for *Gone Again*, the album that inaugurated her new life and career.

The pictures are pretty much the same picture. Patti *was* the same person. She was photographed many times, most famously by Robert Mapplethorpe, who was a close friend. It's flattering to think that Patti believes that my pictures revealed something no one else saw. I'm always perplexed when people say that a photograph has captured someone. A photograph is just a tiny slice of a subject. A piece of them in a moment. It seems presumptuous to think you can get more than that.

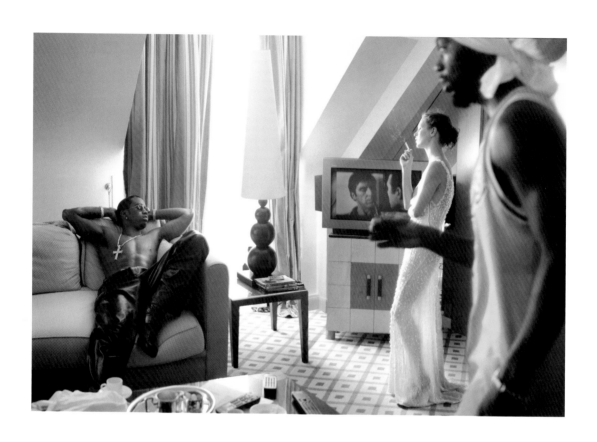

Puff Daddy and Kate Moss, Paris, 1999

FASHION

Bea Feitler used to tell stories about going to the couture collections in Paris with Richard Avedon in the 1960s. Bea was the art director of *Harper's Bazaar* then, and they would have to see the shows and photograph the dresses in a few days. Magazines battled over who was getting the clothes first. The magazines would have them at night and the buyers had them during the day. Photographers and editors stayed up working around the clock and everyone got drunk and crazy and wild. I listened to Bea's stories with awe. I thought of them when I went to Paris to cover the couture collections for *Vogue* for the first time in 1999. I was thrilled to be in Paris shooting those clothes. They're like pieces of sculpture. I couldn't believe that Anna Wintour had asked me to go. The scene that Bea described was long past, but I would see some great shows in Paris over the next few years—Galliano's show in the Orangerie at Versailles, some amazing Alexander McQueen shows. They were like performance art.

I had done fashion work a few times before. The first time was in 1977 when I went to Plains, Georgia, Jimmy Carter's hometown, to do a shoot with Margaux Hemingway for *New West* magazine. Carter had just become president, and we shot in front of his house, and in a peanut field, and in the back room of his brother Billy's gas station, where the cases of beer

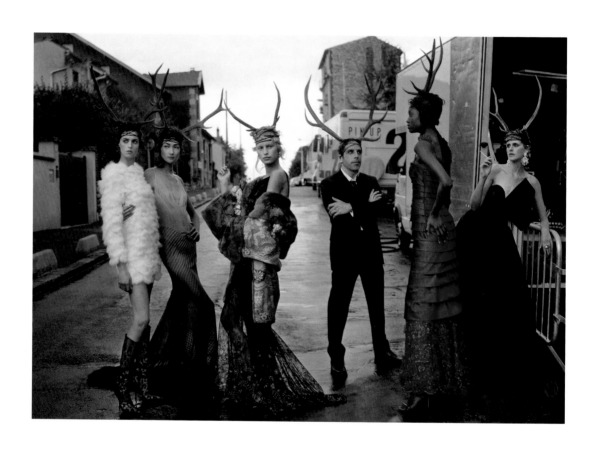

Ben Stiller, Paris, 2001

were stored. The clothes were typical of the late seventies. In the gas station picture Margaux was wearing gold lamé pants. It was like a Vargas pinup. Way Bandy and Maury Hopson, who were stars in their own right, did the makeup and hair. Margaux was good friends with them and I saw how a team can work. It was very illuminating, although I didn't make much use of it until twenty years later.

Before I left for Plains, Bea had given me some advice. "You can take the picture any way you want," she said. "But you must always see the clothes. You must be true to the fashion." That has stuck with me. It was good advice, and I think of it now, when I'm working with truly great, beautiful clothes.

Everyone loves being photographed for *Vogue*. Not just because of the magazine's stature and the tradition behind it but also because they know they are going to be taken care of. They are going to look good and they don't have to worry about what someone writes about them. It's not investigative reporting. Anna came up with the idea of using Puff Daddy, as he was called then, for the collections. I wasn't so sure at first, and then I realized she was absolutely right. The juxtaposition of rap culture and high fashion made things interesting. We concocted a story about Puff Daddy meeting Kate Moss at a party and having a romance in Paris. It was a little bit like the story Avedon did for *Harper's Bazaar* in 1962 with Mike Nichols and Suzy Parker. They played two movie stars having an affair. Trying to escape from the paparazzi at Maxim's.

Putting together a shoot like this is not dissimilar to making a small movie. You have to have everything planned before you get on the set. A large team is involved and there are many meetings. Most of the time is spent on pre-production work. When I'm shooting, I use a storyboard with thumbnail pictures so that I can make sure that people are in the appropriate place in the photograph in terms of how it will look in the magazine.

We started out by going to all the runway shows and looking at clothes. I worked closely with Grace Coddington, the *Vogue* fashion editor. I don't think that Grace was entirely convinced that I could carry this off at first, but she's a pro and she stuck it out. She chose clothes that would work with the scenario we had storyboarded. Puff Daddy was giving a party at a trendy

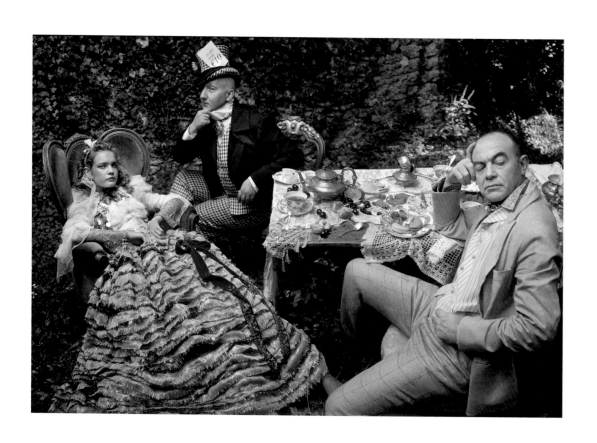

Natalia Vodianova, Stephen Jones, and Christian Lacroix, Paris, 2003

restaurant and we decided to shoot our party scene there. It was big and loud and insane, but we managed to rope off an area to work in. Anna wanted several designers in the picture, and the idea was that Kate would be talking to them. Puff Daddy was supposed to be on the right-hand side of the picture, looking across at her. Seeing her for the first time. Jean Paul Gaultier, Karl Lagerfeld, Oscar de la Renta, and John Galliano had all taken their places when Puffy came in and sat down and said, "Annie, I got to speak to you." We stepped away and he said, "Annie, I didn't come all the way to Paris to be on the side. I want to be in the middle." I looked at him and said, "You don't want to be in the middle." It was a horizontal picture that went across two pages and I tried to explain to him about the gutter of a magazine. The fold in the middle. It didn't matter. So he sat in the middle. But I was working with two frames, and when I got back to New York I just took the right-hand side and put it on the left-hand page. So even though he was shot sitting in the middle, in the finished spread he was on the side.

I used to take pictures where the center was very strong, but I had to stop doing that. You can never put anything in the gutter. It's like a third person. Or a canyon. When I'm editing pictures I sometimes pick them up and bend them. They might look better when they're flat, but a picture in a magazine is a different animal. No one ever sees the picture flat. For all the scenes with Puff Daddy and Kate I used the two frames across two pages. Puff Daddy was with us for two days and on the third day we worked with Kate alone, doing straightforward fashion shots in an old paint factory.

Anna was very smart to ask Kate to work on my first couture shoot. It is hard to fail with Kate Moss. I was used to photographing people who don't like to be photographed, and here I had someone who likes it. Kate trusts you. She's seductive. She knows how to wear clothes that are difficult. She moves her body to give two or three ideas about how the clothes can look. It seems simple, but there's more work involved than is apparent. The other revelation for me was that clothes are like a person. Some dresses are made to be sat in, but most look better when the model is standing up. It's like the good and bad sides of the sitter in a portrait. I love dresses with volume, but I didn't know what to do when they gave me a skinny dress, like the one

Kate is wearing in that hotel room with *Scarface* on the television. It was a gorgeous dress, and Kate knew what to do with it.

My second big couture shoot was done two years later with Ben Stiller. He had just made *Zoolander,* a comedy about male models, and I decided to shoot a series of send-ups of fashion photography clichés. In one scene, Stiller and several very tall models are standing around with antlers on their heads, as if they were in a Bruce Weber shoot. In another photo, two Helmut Newtonish girls in black evening gowns are lying together next to a swimming pool. I was seven and a half months pregnant at the time, and one morning at 5:30 I found myself on the quai, shooting an homage to some famous photographs by Melvin Sokolsky of models in a plastic bubble. We had reproduced the bubble and hired a crane and gotten some kind of permission to do this, although that was all left a little vague. Stiller rather tentatively got in the bubble and the crane lifted it over the Seine. Stella Tennant stood on the side looking arrogant in a red Christian Lacroix gown.

We winged it a bit on those first couture shoots. Some of the scenes were put together at the spur of the moment. When I started doing shoots based on literary fantasies, things had to be more tightly controlled. For the *Alice in Wonderland* shoot, designers were asked to make dresses for Alice and then the designers themselves were cast in specific roles for the photographs. John Galliano was the Queen of Hearts. Tom Ford was the White Rabbit. Viktor and Rolf were Tweedledum and Tweedledee. Christian Lacroix was the March Hare. Natalia Vodianova was Alice. She's another great model and a good little actress.

The 1939 film version of *The Wizard of Oz* was the primary reference for the Oz fashion shoot. Keira Knightley played Dorothy and we cast artists in the other roles. Jasper Johns was the Cowardly Lion. Jeff Koons was one of the Wicked Witch's flying monkeys. Brice Marden was the Scarecrow. Chuck Close was the Wizard. Most of the scenes were shot in upstate New York. For the scene with Kara Walker as Glinda the Good Witch we brought in the Penn State marching band. They marched up and down the Yellow Brick Road. What's great about doing the *Vogue* work is that it seems completely appropriate to go over the top. *Vogue* is about dreams and fantasy.

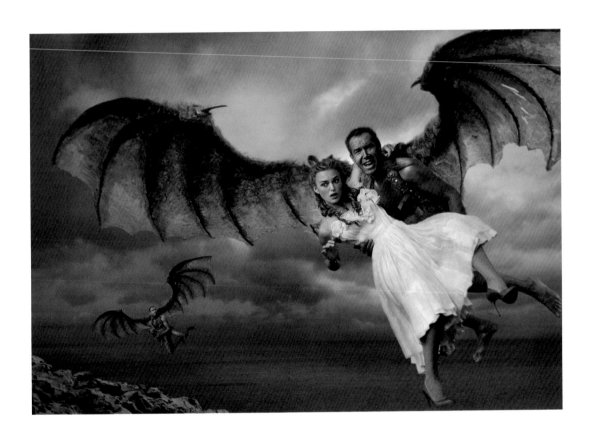

Keira Knightley and Jeff Koons, Goshen, New York, 2005

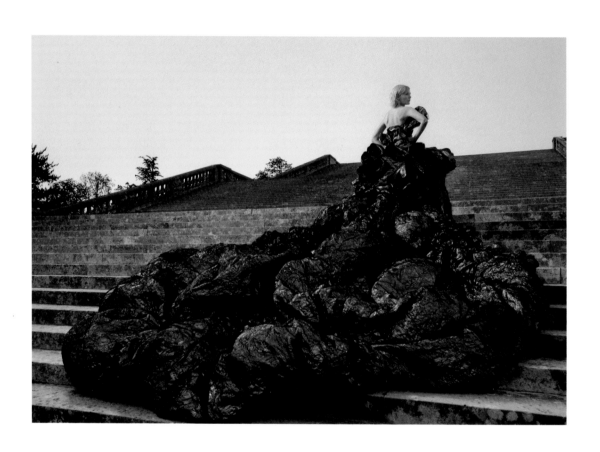

Kirsten Dunst, Versailles, 2006

The Chateau de Versailles was opened up for a fashion shoot for the first time in twenty-five years when we went there to take the Marie Antoinette pictures. Sofia Coppola's film was coming out and her star, Kirsten Dunst, was my model. Most of the pictures were going to be done at Versailles, but I thought I would also try to get into the Conciergerie, on the Ile de la Cité, near Notre Dame, where Marie Antoinette was imprisoned. Her cell is still there, although I never assumed I was going to be able to get into that exact one. I just wanted a generic dungeon. With an Irving Penn background gray. There was some miscommunication, however, and the French got very upset, thinking that I was going to do something sacrilegious. Then I started getting discreet messages from Anna saying that she didn't want "depressing" pictures. She wanted the happy part of Marie Antoinette's life, not the guillotine part.

I was determined to do one dark picture, so my French producer made arrangements for us to shoot at an old chateau north of Paris where in the eighteenth century the owner had kept two bears in a cave on the grounds. We shot Kirsten in a Rochas pannier dress at the bottom of the cave. She was illuminated by natural light, augmented by a strobe, that came through bars over a large opening at the top of the cave. It was very beautiful, although Anna put up a bit of a struggle about running it.

NUDES

The series of nudes used for the 2000 Pirelli calendar came out of working with dancers from the Mark Morris Dance Group at the White Oak Plantation in northern Florida. Dancers are very interesting to photograph. Even when they are still, their bodies retain a sense of movement. They have a kind of grace that you're not going to get from anyone else. And most dancers don't mind taking their clothes off. They express themselves through their bodies.

Pirelli is an Italian company with a core business in high-end tires. Its corporate calendar is essentially a pinup calendar produced in a limited edition for clients in the United Kingdom and Europe. You can't buy it. The assignment pays extremely well, which is one of its attractions for photographers. Richard Avedon did two Pirelli calendars. Bruce Weber, Norman Parkinson, and Bert Stern have all done them. The pictures are usually sexy in a conventional, rather glitzy way, and they serve as a showcase for models. The nude photographs I had made at White Oak were intended for my book *Women,* but I decided that they might seem exploitative in that context. In the context of the Pirelli calendar they were genteel. I liked the idea of changing the direction of the calendar a bit for the end of the millennium.

We finished the project in an old dairy barn on my property in Rhinebeck,

Lauren Grant, White Oak Plantation, Florida, 1999

June Omura, Rhinebeck, New York, 1999

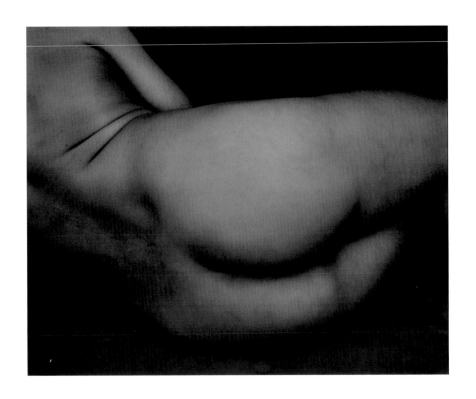

June Omura, Rhinebeck, New York, 1999

in upstate New York. I had never done pure nudes before, but I had been studying nude photographs for years, and I looked at hundreds of them to prepare. Alfred Stieglitz's nude portraits of Georgia O'Keeffe are probably my favorite pictures. They're so intimate and sensual. You can tell that he is in love with her. There's a give-and-take in those sittings that occurs only between lovers. You see that kind of tenderness in Edward Weston's nudes of Charis Wilson, and in Robert Mapplethorpe's early studies of Patti Smith, and in Imogen Cunningham's nudes of her husband on their honeymoon on Mt. Rainier. Most male nudes go overboard. Cunningham's pictures of her husband have a peaceful quality. She's not trying too hard.

There are all kinds of love. The emotional intimacy and trust between a parent and child are conveyed in the beautiful, sensual nude pictures Weston made of his son Neil's torso. And in Sally Mann's pictures of her children. I suppose that in the case of the Pirelli nudes I was influenced most by Weston. Some of his greatest nudes are the ones he made in the late twenties of a dancer, Bertha Wardell. They were lovers, but the pictures are primarily exercises in composition and form. Weston, and Mapplethorpe, too, were formalists. My familiarity or acquaintanceship with the dancers in Mark's company didn't have anything to do with the photo sessions, which were more like life-drawing classes than anything else. I think the dancers thought of them as performances.

I didn't start off thinking that the pictures would be so dark. That look was almost accidental. The first few Polaroids we took were badly exposed, and I loved them. As soon as you opened up the correct exposure they weren't as interesting. Whatever the meter reading was in the barn, we went down about two stops. The natural light was supplemented by lights that had recently been designed for music videos. They produced very flat light. The flattest light I'd ever used. As the light hit the body it would fall away, creating soft shadows and almost translucent shapes. I thought it was gorgeous. Very fleshy and strangely green. But there was very little information in the negative. My assistant begged me to get a brighter exposure. He said we could darken the print down later. I hear this all the time, even in digital work. The technicians will say, "You can't expose it like that. There's

no detail. It's blown-out." But sometimes I want it to look like that. I don't want to play it safe. And I lose control of the process if I don't get what I want when I'm shooting. The nudes didn't have the translucent quality when the film was exposed properly.

It had not been my intention to shoot bodies with no heads. In the beginning I took some pictures of complete figures, but when I saw the way faces were rendered I realized that the flat light wasn't right for them. The light falling off the body made the body more beautiful, but it didn't work on faces. It was distracting. The faces needed more directional light. And faces added personality to the picture, which didn't seem right. The pictures are studies, not portraits.

GROUPS

Some pictures attain resonance as documents of their time. That's certainly true of the photograph of George Bush and several members of his administration taken early in December 2001 for the cover of *Vanity Fair*. There was a sixteen-page portfolio inside the magazine, with individual portraits of the president, Laura Bush, Dick Cheney, Donald Rumsfeld, John Ashcroft, and other key figures in what had recently become known as the war on terror. I don't know why they agreed to let us do this. We were in the White House for two days setting up equipment and shooting. I suppose they felt more self-righteous and confident than ever at that point. The war in Afghanistan was working. Kabul had just fallen, and—as we now know—a few days earlier Bush had initiated secret plans for the war in Iraq. It was a heady moment for them. I didn't direct this portrait very much except to ask the president to put his hands in his pockets. He's a cocky guy with a Texan swagger.

Bush suggested that we shoot the cover photograph in the Oval Office, but I'd worked in the Oval Office several times before and I didn't want to use it. I've had nothing but problems with that line of windows behind the president's desk. They're very distracting. Famous photographs have been taken in the Oval Office, but most of them are black and white and use the

Secretary of State Colin L. Powell, Vice President Richard B. Cheney,
President George W. Bush, National Security Adviser Condoleezza Rice,
White House Chief of Staff Andrew H. Card, Jr., C.I.A. Director George Tenet,
Secretary of Defense Donald Rumsfeld,
Cabinet Room, the White House, Washington, D.C., December 2001

windows to create a silhouette of the president. When I photographed Bill Clinton there after he became president we were kept waiting for hours. By the time we went in to take the picture, the sun had gone down and the windows were dark. But there's no other place in the room to shoot. The wings of the Oval Office look like reception areas. Anyway, why shoot in the Oval Office unless it looks like the Oval Office? I'd pretty much given up on it. Also, I didn't like the way Bush had decorated it. Too many Remingtons.

I asked where the War Room was and someone suggested that perhaps the Cabinet Room would do, so we set up the equipment there. We had a very short period of time in which to get this shot. My assistants and Karen Mulligan, my studio manager, and Kathryn MacLeod, my producer from *Vanity Fair,* acted as stand-ins for pre-lighting. We had been given the exact height of everyone who was going to be in the picture.

The unforeseen element in this sitting was the extra person added at the last minute. We pre-lit for a portrait with six people and then shot seven. The group walked in with Andrew Card, Bush's chief of staff, and I was told that he would be in the picture too. The composition was better with six people, but there was nothing to be done about it. Andrew Card didn't add much in terms of historical significance. He is remembered principally as the man who came up to Bush at the elementary school where the president was being filmed observing a class on September 11 and whispered in his ear that a second plane had just flown into the World Trade Center.

The portrait was created from two frames. The sides were trimmed on the published photograph to make it fit the cover of the magazine, which explains why Colin Powell looks a little cramped. I was using two frames a lot at that time because my camera, the Mamiya RZ67, had a squarish format and I prefer a wider frame. Putting two frames together broke the boundaries imposed by the lens. Trying to get everything into one rectangle is frustrating. You look around and you see so much more than the camera does. I tried to transcend the frame for the first time in 1969, when I was a student, on my way back to San Francisco from Israel, where I had been working on a kibbutz. I took a bus to Paris and walked to La Passerelle des Arts, the footbridge next to the Pont Neuf. I was so excited to be in the spot

where Henri Cartier-Bresson had stood that I turned in a circle and shot 360 degrees of pictures. But it was David Hockney's photographic collages that most inspired me to open up the frame. I was floored by how close Hockney's pictures came to the way the human eye sees. Hockney assembled the whole picture from individual shots of its parts. He said he thought that was more honest than a single frame, closer to the truth of experience.

I began putting multiple frames together when I had to shoot large groups for *Vanity Fair*. In 1995, for the first Hollywood issue, which has become an annual event around the time of the Oscars, I photographed thirty-seven people, plus a dog and a horse, for a four-page foldout commemorating the actors in the old studio system. Some of these people were very old and this would be the last significant photograph taken of them. We had Gene Autry, Ginger Rogers, Roddy McDowall, Richard Widmark, Shelley Winters— really important stars. It hadn't occurred to me yet that I could piece the shot together, so I used a Widelux camera, which has a long negative that could accommodate the whole group. But the Widelux was a disaster. The figures at the sides of the frame were distorted. Heartbreakingly so. Douglas Fairbanks Jr.'s head looked like it had been flattened out with a rolling pin.

The cover of that first Hollywood issue was a three-page foldout of ten actresses. I shot them using a method based on the way we worked when we scouted locations. We would pan across an area with Polaroids and then tape the frames together. The first Hollywood cover shoot was arranged very meticulously. There were three cameras on tripods for the three frames, and everyone was carefully lined up. The picture was OK, but I thought it looked a little strange, since there wasn't a single point of view. The panels didn't quite fit together, and the perspective was off. I worked on this problem for a while, and eventually I began doing the Hollywood issue covers by shooting one frame for the front panel, the one with the logo and type on it, and for the second and third panels I would use another camera to pan across the rest of the group. The people in the third frame were angled toward the camera, so as I turned to the right they were brought in a little tighter. This was all done on film, which was then scanned into a computer and a new negative was produced.

Warren Buffett, Frank Biondi, Richard Parsons, John Malone, Bob Wright,
Howard Stringer, Edgar Bronfman, Jr., Ron Meyer, Andrew Grove, Terry Semel,
Ralph Roberts, Rupert Murdoch, Nathan Myhrvold, Gerald Levin, John McCaw, Jr.,
Jeff Berg, David Geffen, Katharine Graham, Bill Gates, Herbert A. Allen,
Nobuyuki Idei, Barry Diller, and Jeffrey Katzenberg,
Trail Creek Inn, Sun Valley, Idaho, 1997

I learned a lot about perspective from taking those group shots, and I started to believe that if I panned the camera to the left and to the right on my regular portraits I could get a picture that was truer to the way the eye sees. It made sense to take two frames for a magazine: the left-hand page and the right-hand page. Two frames from the Mamiya RZ67 made something similar to the dimensions of a 35mm rectangle, the frame size I have always preferred. When you put two of the Mamiya's frames together you created a very large negative. So you got handsome pictures taken with a normal lens, no distortion, plus the tweak of perspective that adds a little on the left and a little on the right. A modified Hockney.

I started using two cameras and two tripods, working close, and at first I made the fact that there were two frames very obvious, leaving the edges visible in the print. Then I didn't think that was necessary anymore, and we just scanned the film for the two images into the computer and made the composite look seamless. I did this for a long time. As often as I would try to go back to one frame, I could never get the same dynamics I did with panning the camera. I loved the larger image. I felt I could see around corners. You could almost get a 3-D effect. Toward the end I would just hold the camera in my hand and swing around. Of course when we put the images together in the computer they didn't always fit together neatly. My assistants started shooting the whole room after I was finished shooting, so that we would have the necessary pieces to add in when the scans were put together.

The photograph of guests at Herbert Allen's retreat for media moguls in Sun Valley in 1997 is constructed from two Polaroid negative frames. This was the second time I'd photographed the Sun Valley conference. The first time was considered something of a coup for *Vanity Fair*, since up until then the retreat had been very secretive. Herbert Allen is a billionaire investment banker who understands the value of relationships with other billionaires. His first Sun Valley conference, in 1982, had thirty-five guests. By the mid-nineties, there were over three hundred adults and a hundred or so children. The children were looked after by an army of Allen & Co. babysitters. The adults participated in panels on subjects of interest to them, went

David Chase, Jamie-Lynn Sigler, Robert Iler, Dominic Chianese,
Nancy Marchand, Edie Falco, James Gandolfini, Lorraine Bracco, Michael Imperioli,
Steve Van Zandt, Tony Sirico, Jerry Adler, and Vincent Pastore, New York City, 1999

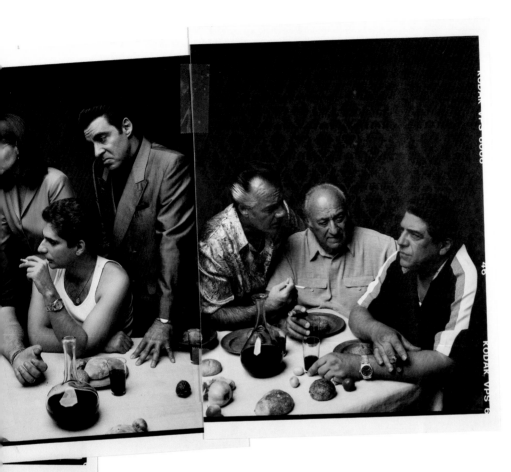

white-water rafting, played tennis, golfed, got massages, and networked. The networking was, obviously, on the highest level. *Vanity Fair* started making the photograph a yearly event, but things got out of hand fairly quickly. The magazine drew up a list of people they wanted in the picture, and Herbert Allen was put in the awkward position of trying to explain to some of the moguls why they had been left out. People's feelings were hurt. The photograph became a distraction from the serious networking business. In 1999, when I finished the sitting, Allen said that would be the last photograph.

The Polaroid negative created an old-fashioned feeling in the picture. I used a Polaroid negative back on my Mamiya a lot during the nineties and later—up until Polaroid stopped producing the film, in fact, by which time I was starting to work with digital. There was more negative on the back of the camera than there was with regular film. And the Polaroid negative was slow. It had an 80 ISO. The prints seemed almost grainless and had great integrity. It felt like you were working with a platinum print. Prints made from film looked boring compared with the beautiful, flattened-out look of the Polaroid negative. Of course it was labor-intensive. The negative had to be immersed in a bath right away. We carried around buckets and solution.

It became apparent to me after a while that shooting two frames to make a picture is not a good thing. The composite picture was two moments. I was missing *the* moment. When I began working with a 35mm digital camera, there was no longer any reason to put two images together. I enjoyed going back to a single frame. It was a relief. There was a lot of work involved in putting the two halves together, and I was starting to leave out the middle.

The photograph of the cast of *The Sopranos* was made in my studio with minimal props. I constructed the image by folding Xeroxes of individual frames and taping them together, and then my model was used to make a file for the magazine. The exaggerated width is true to the da Vinci *Last Supper*, and it conveniently fit into a three-page foldout. The picture was taken shortly after the first season of the series aired. The actors were a little taken aback by all the attention they were getting. James Gandolfini was reluctant to assume the central position as Christ, but he was persuaded that it wasn't blasphemous.

The pinnacle of group shots for me was the one for the ninetieth anniversary of Paramount Studios, in 2002. It was the best organized, the best set up, the best produced. We had ninety-four people on three tiers of scaffolding in front of the original studio gates. It took several days to build the set. Stand-ins were cast for each person who would be in the final picture. We worked with the stand-ins for two days. We were shooting for a three-page fold-out, and three Mamiyas were set up on tripods. I moved from camera to camera. When it was time for the shoot, a fleet of golf carts brought the stars to the scaffolding and they were escorted onto it. I had those old-fashioned studio shots in mind, where you can see everyone and everyone is equal. I concentrated the older stars in the middle, up front. We had James Coburn, Charlton Heston, Sidney Poitier, Ernest Borgnine, Jane Russell, Mickey Rooney, Rhonda Fleming. The actual shoot took about twenty minutes.

What I hadn't taken into account was how small everyone would be when the picture was printed in the magazine. If you blew it up, it was beautiful, but in the magazine everyone looked tiny. The Paramount picture is special. It documented an extraordinary group of people. I have learned how to organize and direct large groups, but I would always rather photograph an individual. No group picture is going to have the power of an individual portrait.

PRESENCE AND CHARISMA

One of the oldest clichés about portrait photography, particularly Holly-wood portrait photography, is that the camera loves certain people's faces. I resisted that idea for a long time. I was skeptical about a subject holding a picture on his own and I would always go into a shoot with some kind of plan to help things along. Over the years, however, I've come to understand, almost reluctantly, that the cliché is true. Some people are photogenic. You see it when you are setting up a portrait with a stand-in. You're having a miserable time and nothing looks right and then the subject walks in and everything is transformed. Nicole Kidman, for one, takes over. There's not a bad way to photograph her. Cate Blanchett is another one. She's always interesting. And Susan Sarandon. Catherine Deneuve. She just becomes Catherine Deneuve. Johnny Depp also has it.

What I'm talking about is not always immediately visible to the naked eye. You sometimes become aware of it during the shoot when you look at a Polaroid or at the screen of a monitor. And it's not just that the camera loves these people's faces. There are quirky things about them that are also beautiful to photograph. The way Nicole Kidman looks from behind when she walks away, for instance. The way she stands. Not many people are good at standing.

Nicole Kidman, Charleston, East Sussex, England, 1997

Glamour is part of the quality I mean, but it can manifest itself in situations that aren't particularly glamorous. In 1997, when Nicole Kidman was in England, making the Kubrick film *Eyes Wide Shut,* I brought her to Charleston, the former home of Vanessa Bell and Duncan Grant, in Sussex. Kubrick had asked her to stay out of the sun for a year or something before they started filming, and her skin was very white. Almost translucent. She sat on the edge of a bed wearing nothing but a black turtleneck sweater, looking directly at the camera. Everything that you would think makes her a movie star was stripped away, and she still held the picture.

The camera is not enamored exclusively with people who are conventionally beautiful. There are times when a person is powerful enough in some other way to make the photograph. The choreographer Mark Morris, for instance, is not only a genius but he's sexually charged and energetic and that comes through on the camera. His total belief in himself is thoroughly projected. Tom Waits is not "beautiful." Nor is Daniel Day-Lewis. Or at any rate they aren't at this particular moment in time. The standards of beauty are more or less fashion trends. William Burroughs was certainly not beautiful, but he was a photographer's dream. The camera loved that gaunt, sinister look.

Being photogenic is a tool of the trade. I remember shooting a magazine cover with the cast of *E.R.* when George Clooney was still part of it, and the cast of *Friends*. We had them all grouped together on scaffolding. They were sitting on video monitors. There were monitors everywhere. We had video cameras focused on their faces while I shot, and the live feeds were on the monitors. I was taken aback by how great they looked. They were TV actors. Had they been chosen because they looked so good in close-ups? Their faces were photogenic in that square.

Actors who are photogenic like being photographed, and I've come to understand that they make the photograph. I realized when I studied pictures of Marilyn Monroe that it almost didn't matter who the photographer was. She took charge. It seemed like she was taking the picture. There are other actors, however, who resist being photographed. They feel awkward. It doesn't seem to them to have anything to do with their work.

Johnny Depp, New York City, 1994

Cate Blanchett, Los Angeles, 2004

Meryl Streep and Robert De Niro are in this category. I have the impression that a photograph seems superficial to them. They associate it with being a star and they think of themselves as actors first. They don't want to be connected to the star machinery. I think also that actors such as Streep and De Niro got into acting to get away from themselves. They like playing roles and they feel cornered by a photograph. They don't feel that projecting their personalities is part of what they do. They associate a photograph with selling themselves.

Cate Blanchett seems to have transcended any qualms about the photographic enterprise. She is an actor deeply committed to the theater—she and her husband spend most of their time in Australia as directors of the Sydney Theatre Company—and she's so self-confident that she doesn't mind becoming whoever you want her to be. She seems to take for granted that having your picture taken is part of her profession. She's grounded in the theater, but she can act like a professional model when called upon. Like any great model, she doesn't mind being used.

BEING THERE

As much as I love pictures that have been set up, and as important as those pictures are to me, I'd rather photograph something that occurs on its own. The tension between those two kinds of photographs is at the heart of what I do. It's not a conflict, but sometimes it's useful to remember that things are happening right in front of you and that you don't have to complicate the situation. You can take what's given to you. You just need your mind and your eye.

I photographed Philip Johnson at the Glass House pretty much by accident. I'm interested in architecture. Houses fascinate me, and the Glass House, which Johnson designed and built for himself in 1949, is certainly one of the most important houses in the world. It's a glass-and-steel transparent vault on forty-seven acres of land near New Canaan, Connecticut. The only floor-to-ceiling interior element in the house is a brick cylinder containing a bathroom and fireplace. Everything else is exposed to the outside. I'd always wanted to see it, and when I photographed Johnson for an Absolut vodka ad a few years ago I asked him if he would arrange a visit for me. He said, Sure, no problem. I planned to photograph the house for a project that Susan Sontag and I referred to as the Beauty book. Anything that we were attracted to, or interested in, could be included in the Beauty

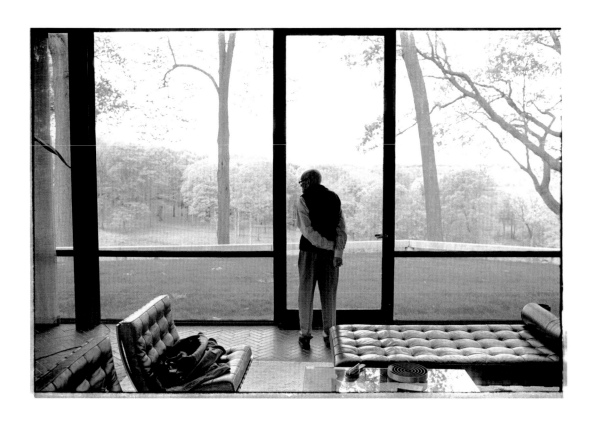

Philip Johnson, Glass House, New Canaan, Connecticut, 2000

book, and we had started making lists. I thought of the Beauty book as a collection of photographs that I would take in an old-fashioned way, when I was moved to.

I was given an appointment and I drove over to the house one weekend. It never occurred to me that Johnson would be there, but he was. This was frustrating. I knew that I should be sociable, but I wanted to study the house. So I was a little grumpy. And he was a little grumpy too. He had assumed that we would chat. I kept saying, Oh, you can go do something else, and I walked around, rather rudely, taking pictures. I did have one small conversation with Johnson. I asked him how the air system worked. He looked at me like I was nuts. He said, Annie, you open the doors.

The situation was awkward, but in retrospect it was a rare opportunity to see someone living in a classic house. To see it being used. It was fall and there were leaves all over. Johnson's dirty boots were thrown on the floor. He was staring out at the rolling lawn and the maple trees, which were changing color. I had always admired the siting of the house, and I remarked on that. Johnson laughed. He had moved every tree in. It was a carefully designed landscape.

Philip Johnson was ninety-four when I visited the Glass House. When I photographed William Burroughs, he was eighty-one and had retired to a small university town in Kansas. The rent went up on Burroughs's place on the Bowery in New York in the early eighties and he decided that the Midwest was a good place to work and grow old in. He bought a rambling bungalow with a garage attached. There was lots to photograph. An old car in the driveway. A wood porch. It was like a set. I'm sure that there were more than a few guns in a closet. The living room had a tattered couch and a writing table. Burroughs laid down on the couch for me. He did everything I asked him to do. And then I ended up taking close-up pictures of his head.

I seem to remember that Irving Penn once said that he didn't want to photograph anyone until they were older, and many of Penn's great portraits are of artists in old age—Colette, Picasso, Willem de Kooning. Their faces show that they've lived. Burroughs had been photographed many times over the years, and he always looked thin and gaunt, but he was more fragile

than I'd imagined. I asked him to sit in the garage, at the back of the house. I shot him in natural light from just inside the garage door, about a foot or two in. That's the best place to shoot someone in natural light. You're out of the direct light. It's diffuse. When I got back to New York and looked at the contact sheets I thought that the head shots were riveting, although they were not the kinds of pictures I usually take. I love Avedon's stripped-down portraits, but I'm very uncomfortable coming in close like that. Avedon trusted the face to take the picture. He didn't claim that his portraits were "true," but they looked like reality. I usually pull back from the subjects of a portrait and include things around them in the picture. That's one of the reasons I love Diane Arbus. I used to study her pictures and try to figure out how she got just the right amount of curtain in a frame. Just a little piece of it, but just the right amount for the room she was working in.

The portrait of Agnes Martin was taken for my book *Women*. It was obvious that Martin should be in the book, although it was not so obvious that she would agree to a sitting. She was famously private. She had left New York in 1967, seeking the solitude and quiet that a successful and well-known painter, which she was becoming, could not find in the city. She had opted out of the commercial aspects of the art world. For years she lived in an adobe-brick and log house that she had built by herself on an isolated mesa in northern New Mexico. Martin was eighty-seven now and living in a retirement community in Taos, where she also had a studio. I was told that if I went to Taos I could meet her, although there was no agreement that I could take a picture. We had lunch in a little café and sort of sniffed each other out. Neither of us talked very much. She seemed shy, but every so often she would utter maybe two sentences that seemed very thoughtful and profound. After lunch we were told that it was OK to come to the studio the next morning for a portrait.

Martin's studio was on the ground floor of a modest adobe building. There was a little bed at the end, under a window, and a dresser, on top of which were some paintbrushes in a metal can. In the area where she painted there was a table with more brushes and a rag and some bowls, and four small paintings propped on top of the table. She hung her canvases on the

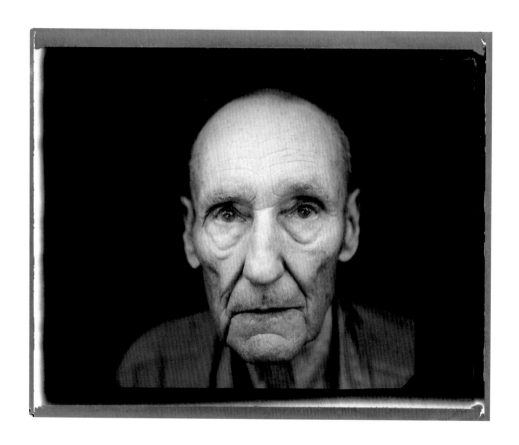

William S. Burroughs, Lawrence, Kansas, 1995

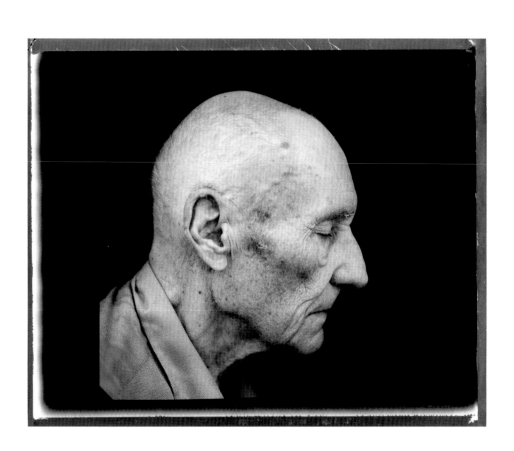

wall by herself. I thought I would photograph her while she was working, the way Alexander Liberman had photographed artists. The way he had photographed Martin, in fact, in the seventies, when she was on the East Coast for the first major retrospective of her work. But we never got to that point. She came to the studio wearing a clean blue shirt, and I took a few photographs of her in it, but then I asked her to put on the striped shirt she wore when she was working. She did, and I shot some black-and-white photographs. The only other person in the room was my assistant, Nick Rogers, who helped me with the strobe on the black-and-white pictures. We shot the color portraits in natural light.

Martin was a serious student of Taoist and Buddhist teachings about awareness and perception and she thought of art as a vehicle for revelation. A path to the sublime. Her paintings were not just Minimalist exercises. They were aspects of a spiritual quest. She wrote once that her work represented the "Ideal in the mind." I asked her what she did at the studio when she came in in the morning, and she said, Well, I sit here and wait to be inspired.

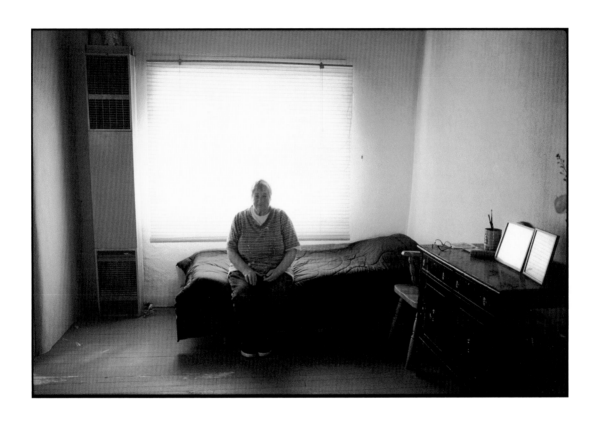

Agnes Martin, Taos, New Mexico, 1999

MY MOTHER

I first photographed my mother in a formal way in 1974, after I had begun working for *Rolling Stone*. I was visiting my parents at a summer cottage in the Catskills and I asked my mother if she would dance for me. The session was a rite of passage. I was a photographer and she was a dancer.

Many years later, when my mother was in her mid-seventies, I photographed her at my place in upstate New York on another summer afternoon. We had set up a chair for her in the shade on the lawn. She was nervous, and when I asked her what was wrong she said she was worried about looking old. She was a strong woman who was accustomed to being in control of situations. It's rare that people expose themselves like that.

I have often said that I don't have a favorite picture, although, as time passes, that portrait of my mother means more and more to me. It's probably my favorite picture. It's honest. My mother is looking at me as if the camera were not there.

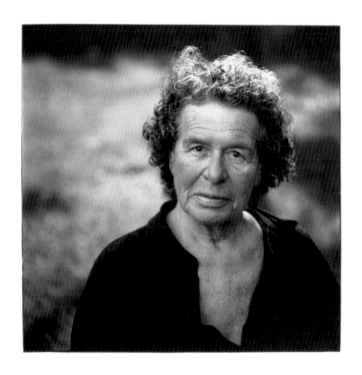

Marilyn Leibovitz, Clifton Point, New York, 1997

SARAH

There are not many smiling people in my pictures. I've never asked anyone to smile. Almost never. Maybe a few times I felt I had to, when people looked really depressed, but I apologized for asking. You can almost hear the sigh of relief when you tell someone they don't have to smile.

Where did "Smile for the camera" come from? It's a tic. A way of directing attention to the camera. "Look at the birdie." The smile is a component of family pictures. Mothers don't want to see their children looking unhappy. My mother would hire a local photographer to make a family portrait and he would inevitably ask us all to smile. They were canned smiles. Forced. In the fifties, everything was supposed to be OK, although half the time it wasn't OK. It took me years to understand that I equated asking someone to smile with asking them to do something false.

There are people who smile naturally. It's their temperament. And you can catch a smile that is spontaneous, of the moment. My daughter Sarah has the most beautiful smile. When you see it occuring so naturally in children you hate to see it lost. I crumbled inside one day when I saw Sarah fake a smile.

Sarah Cameron Leibovitz, New York City, 2002

Susan Sontag, Paris, 2003

SUSAN

When Susan Sontag's book about photography and war, *Regarding the Pain of Others,* was about to be published, she asked me to take her portrait for the jacket. I photographed her in Paris, across the street from our apartment on the Quai des Grands Augustins. It was my last sitting with her.

HOLLYWOOD

The centerpiece of the 2007 *Vanity Fair* Hollywood issue was a series of pictures that told a classic, if perhaps slightly muddled, *film noir* story involving a dead private eye, a blond heiress to a lemon-grove fortune in Los Angeles, a tough homicide detective, a tabloid photographer, and several other characters along those lines. It took up thirty-three pages in the magazine. Michael Roberts, the *Vanity Fair* fashion and style editor, came up with the idea. It was similar to the kind of thing I had been doing for *Vogue,* only in this case the scenario was determined by a genre rather than by a specific story like *The Wizard of Oz* or *Alice in Wonderland.* Michael roughed out a narrative line and then I took it apart and looked at the pictures that interested me and rebuilt it. Some of the scenes are based on real films and some of them refer to elements in three or four different movies. Several were scenarios Michael made up.

The story is an homage to a style that flourished in the forties and fifties but it is placed in the present. The clothes aren't costumes. They're modern clothes. The car at the murder scene is a 1964 Chrysler Imperial. The most obvious departure from noir style is that the story is not shot in black and white. Black and white is limiting as far as tone goes. You have to light it very bright and hot. I had begun using a digital camera several months

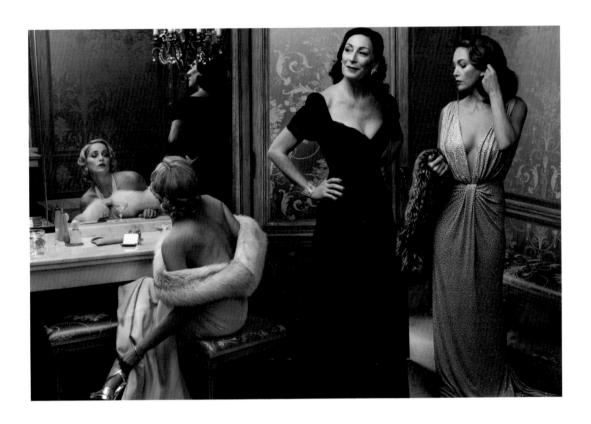

Sharon Stone, Anjelica Huston, and Diane Lane, Los Angeles, 2006

Kirsten Dunst, Bruce Willis, and James McAvoy, Los Angeles, 2006

before the shoot, and I felt that I could get a sort of twilight feeling using digital color. I was setting the strobes maybe half a stop under the natural light. Occasionally the strobe would lag behind the camera, and the frames that had only natural light looked better to me.

The cinematographer Vilmos Zsigmond worked with us for this portfolio. It was interesting to get his take. We would roughly light a scene and then Vilmos would say, What about this or that? In the beginning he wanted us to use more small hot lights than strobes. You have more control with the small lights. But by the end of the shoot, Vilmos saw the advantage of a fast light source. You're stopping motion and you have better depth of field. Vilmos showed us how to light the street in the murder scene in the rain with Bruce Willis and Kirsten Dunst and James McAvoy as the Weegee figure. There was a big Bebe night light—a bank of twelve HML lights—flooding the background, but the foreground was shot with just the light from the old Graflex that James McAvoy was holding. The flashbulbs had to be changed each time we shot.

The murder scene was shot on a set we built on the Universal backlot. I was reluctant to have sets built, and it seems to me that the most successful pictures are the ones we took on location. The picture with Jack Nicholson was taken where he lives. It's his view from Mulholland Drive, overlooking the Valley. And that fire escape Helen Mirren and Kate Winslet are standing on is at a real hotel in New York, in the West Forties. I always prefer to be in a real place. To make that part of the picture. The first shoot we did was with Anjelica Huston and Diane Lane in the powder room of the Dorothy Chandler Pavilion. We had in mind the powder-room scene in *The Women*. It didn't take long to shoot. Diane came on the set, and then Anjelica, and they were so good that we were finished in literally ten minutes. This happened again and again. The shoot with Jack Nicholson was over in less than half an hour. These people are pros. Craftsmen. You couldn't get that kind of work out of them in a portrait session. They were pulling things out of places in themselves that they use when they act.

A story like this is complicated, with many parts, and working digitally made things easier. Not everyone was available at the same time or in the

Judi Dench and Helen Mirren, Los Angeles, 2006

Helen Mirren and Kate Winslet, New York City, 2006

same city, for instance, and it was possible to photograph someone later. Sharon Stone was photographed after I shot Anjelica Huston and Diane Lane. The picture of Helen Mirren and Judi Dench in the car was made in two different places. It was fun directing Judi Dench to act like she was talking to someone who wasn't actually there. She was saying, "You bitch. How could you have done that to me? Why did you do that to me?" And she had that look. If we had been using film, we would have had to stitch two frames together, but since we were shooting digitally, we built the final picture in the computer.

I was afraid to start working digitally. It was a whole new world. And in the beginning it meant working with more people. It was a tough transition. The digital technicians weren't patient with my film assistants. There were a lot of fights. The digital guys thought they were superior to the film guys, and the film guys thought the digital guys were acting like smarty-pants. The digital guys made it sound like it was all smoke and mirrors. But I learned to love digital. The technology has transformed the way we work. The more I use it the more I appreciate the possibilities.

Jack Nicholson, Los Angeles, 2006

THE QUEEN

The pictures of Queen Elizabeth were taken a few weeks before she visited the United States for the 400th anniversary of the founding of Jamestown. I was the first American to be asked by the Palace to make an official portrait of the Queen, which was very flattering. I felt honored. I also felt that because I *was* an American I had an advantage over every other photographer or painter who had made a portrait of her. It was OK for me to be reverent. The British are conflicted about what they think of the monarch. If a British portraitist is reverent he's perceived to be doting. I could do something traditional.

It's ironic that the sitting with the Queen became controversial. I'm rather proud of having been in control of a complicated shoot. The controversy arose about two months after the pictures were published, when the BBC claimed that the Queen had walked out while we were shooting. This was completely untrue, and although they retracted the claim and issued an apology to the Queen and to me almost immediately, the scandal had a life of its own. The story, which came to be referred to as Queengate, wouldn't die. Eventually the head of BBC One resigned because of it.

When I was preparing for the shoot, I thought about using the landscape around Balmoral Castle, in Scotland. I brought this up in the first confer-

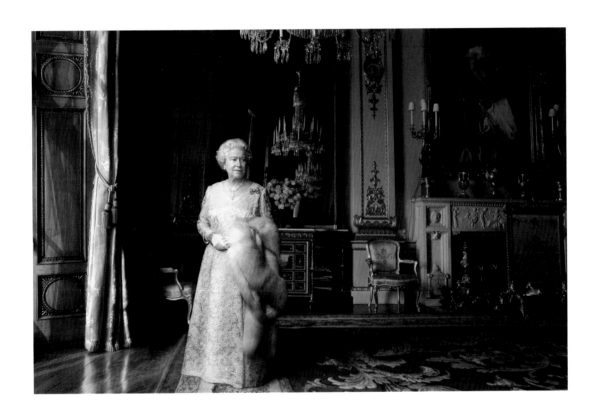

Elizabeth II, Buckingham Palace, London, 2007

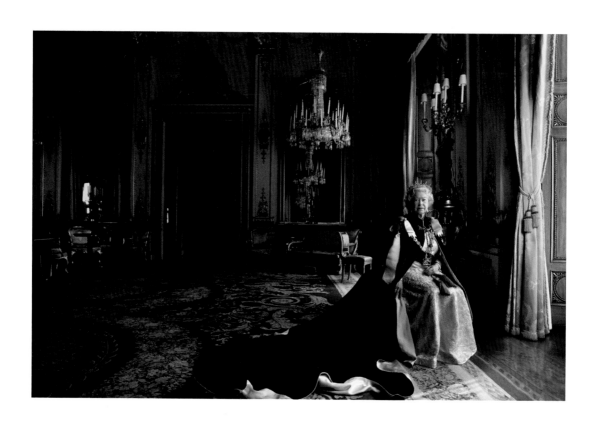

Elizabeth II, Buckingham Palace, London, 2007

ence call with the Palace. I said that Americans thought of the Queen as an outdoors woman. I had been influenced by Helen Mirren's performance in *The Queen* and I couldn't help mentioning how much I liked her character in that film. There was a long silence on the other end of the line.

The second idea I had, after Balmoral, was to photograph the Queen on horseback. I asked where she rode and they said she went riding every Saturday at Windsor Castle. I said that I would love to see her in her riding clothes, and in a later conversation I asked if she could stop during her weekend ride and get off her horse and mount it again. That is, could I do a portrait of her in the trees. They said no, it was not possible. She just rode the horse and came back, and anyway, she didn't wear riding clothes anymore. A few days later they said it was going to be Buckingham Palace and no horses.

I realized that I was going to need some time on the ground for this. I asked if I could come in on a Monday and scout the palace and then set up the next day. We would shoot the day after that. By this time we were talking about whether the shoot would be inside the palace or in the gardens. They said that they doubted that the Queen would go outside, because the weather wasn't good, although she did take walks twice a day. I was thinking that we could dress her formally and have her stand outside. I had in mind the portraits Cecil Beaton did of the Queen Mother in the gardens.

The Queen is the most photographed woman in the world, but I'd never looked at photographs of her with the idea that I would be taking her picture. In the famous Dorothy Wilding portraits of the Queen made in 1952 for the coronation—the portraits that were used on stamps and banknotes—she is very young. The Palace sent me some photographs that had been taken for her Golden Jubilee, the fiftieth anniversary of her accession to the throne, when several photographers were each given five minutes to take her picture. The most informative one was taken by her son Prince Andrew. She was smiling at him. That was a specific look I wasn't going to get.

The people at the Palace were concerned about what I was going to do. I was reminded of the Karsh shooting with Churchill, where Karsh took the cigar out of Churchill's mouth and got that great, scowling shot. I didn't

intend to do anything like that. The portrait that stood out for me was one of Cecil Beaton's last pictures of the Queen. She is wearing an admiral's boat cloak, and the photograph is very stark and simple and strong. To alleviate fears, I began saying that Cecil Beaton was my point of reference. A few people, including the Queen, would tell me that I had to find my own way. Besides those early photographs of the Queen, the Lucian Freud painting interested me. I didn't understand it. It seemed more of a portrait of him than a portrait of her. And he seemed to dismiss her by making it a painting of just her head. I prefer to photograph the full body. But I read that the Queen liked the portrait Freud did, which meant that she understood that her role would be interpreted in many ways.

When we arrived in London on Monday we went straight to the palace and were shown all the rooms, including the throne room—everywhere except the private quarters. And then we did a scout of the back. There was a wintery sky and the trees didn't have leaves. It was an appropriate mood for this moment in the Queen's life. There was no way, however, that she was going to stand outside in formal attire.

For a sitting like this you don't put all your eggs in one basket. You try to have as many options as possible. I kept thinking that somehow I would get the Queen outside, but I began choosing formal outfits. I narrowed the robes down to a very handsome Order of the Garter cape, but then we were told that she could only wear a white dress under it. We were lobbying for a gold dress. I was also hoping for a dress with more body to it. The Queen wears very streamlined dresses now that she's older, and I wanted her in something with more volume. But she didn't have anything like that. Finally everyone agreed that she could wear a gold-and-white dress under the Order of the Garter robe.

The Queen was eighty years old. She was sturdy, but putting on and taking off a lot of heavy clothes is tiring, and she had to be dressed in layers to expedite things. The gold/white dress became the base. Then when we looked through the books of photographs of clothes in the press secretary's office we found some fox stoles that made her look a little slimmer when she sat. So we had a stole, the gold/white dress, and the Order of the Garter

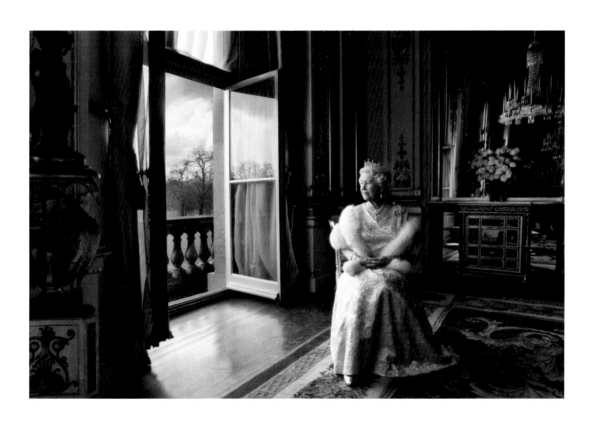

Elizabeth II, Buckingham Palace, London, 2007

robe. I also chose a diamond tiara given to the Queen by her grandmother as a wedding present. The crown that Lucian Freud used was amazing, but I wanted something lighter.

I was still upset that I couldn't get her outside. It was so beautiful out there. And it wasn't cold or raining or anything. I began thinking about what Cecil Beaton had done. He brought in flowered backdrops. Beaton was big on backdrops. Perhaps because the pictures were made in black and white you don't notice them. They sort of go out of focus. By Monday night I realized that I could do something similar digitally. I decided to photograph the garden and the trees for a backdrop.

The pictures of the trees were taken on Tuesday. That night there was a reception at the palace for Americans, before the Queen's trip to the United States, and when I met the Queen there she asked me if I had found a room to use. She knew what we had been doing to prepare, which is pretty unusual. I had decided to talk to her about being photographed, and I mentioned Dorothy Wilding, who was the first woman to be appointed an official photographer for the royal family. Wilding took the 1937 coronation photographs, when Elizabeth's father became King. She was very well known, with chic, modern studios in London and New York and many commissions. There are fifty-nine different poses from Wilding's sitting with Elizabeth in 1952. I said that I was proud to be in such distinguished company, and the Queen snapped back, "Well, she wasn't even there! A man took my picture." Really, I said. And she said, "She wasn't in the room."

I decided to change the subject. I reminded the Queen of another woman photographer, Jane Bown, who took the Queen's eightieth-birthday portrait for the London *Observer*. Bown, who is the same age as the Queen, doesn't use assistants. She came to the palace alone, carrying two bags full of equipment. I had been told that the Queen helped her move the furniture around. Bown took some quite nice black-and-white pictures. Very simple, but nice. (What everyone thought of as a "nice" picture of the Queen was one in which she was smiling.) When I brought up this story, the Queen seemed very pleased. "Yes, she came all the way by herself!" she said. "I helped her move the furniture."

"Well, tomorrow is going to be the opposite of that," I said.

The Queen moved away, and her press secretary came up and said that she thought the Queen and I had very good chemistry.

I checked later about the Dorothy Wilding story. It seems that, indeed, Wilding's assistants, who were trained in her style, often took the photographs. At one point she employed thirty-seven people, including retouchers and printers, in the London studio, but by the early fifties she was spending most of her time in New York.

The Palace had given us twenty-five minutes with the Queen, so there had to be a battle plan. I chose a grand reception room, the White Drawing Room, as the principal setting because of the light from the tall windows. Supplementary lights had been pre-set so that when the Queen moved from one spot to another they just had to be switched on. We had constructed a gray canvas backdrop in an anteroom, and she was to come in there wearing the Order of the Garter robe and the dress, but no tiara. The first shot was to be made on a balcony, with the sky behind her. That sky could be digitally exchanged later for the pictures I had taken in the gardens the day before. I didn't want her to be wearing a tiara in the gardens. After the balcony shot she was to walk into the drawing room and I was going to shoot her in one direction and then turn around and shoot her in the other direction. It would be as if you were looking at the whole room.

The morning of the shoot, the Queen came walking down the hall very purposefully. She was definitely a force. This was all being taped by the BBC for a documentary. I would never have agreed to them being there if I felt I had any choice, but they had been following her around for months. Their microphone picked up her saying, "I've had enough of dressing like this, thank you very much," as she marched down the hall. Later, when segments of footage for the BBC were edited for a promotional film, it appeared as if the Queen were stomping out of the photo session rather than going into it. Thus the brouhaha.

The Queen was about twenty minutes late, which we thought was a little strange. When that happens, you never know if it can be made up on the other end. My five-year-old daughter, Sarah, had come with us, and she

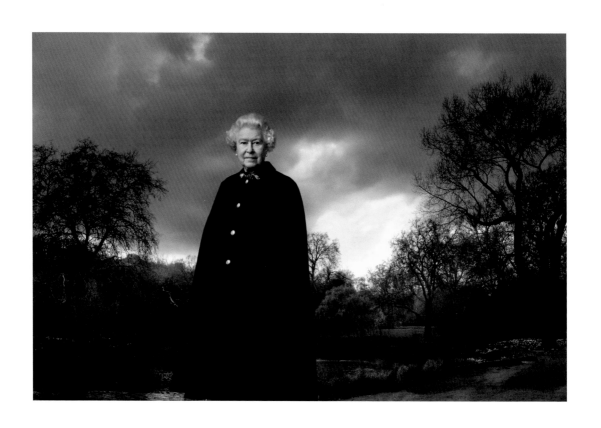

Elizabeth II, Buckingham Palace, London, 2007

curtseyed and offered the Queen flowers and I introduced my team. At this point I was in shock. The Queen had the tiara on. That was not the plan. It was supposed to be added later. The dresser knew that. The Queen started saying, "I don't have much time. I don't have much time," and I took her to the first setup and showed her the pictures of the gardens. I think she understood what we had in mind. Then I walked her into the drawing room, probably sooner than I would have if things were going well. She composed herself when I took some pictures. That's when she said, "I'm not a very good dresser." It was touching. I found out later that the Queen does her own makeup. She gets her hair done once a week.

I knew how tight everything was, especially with the loss of twenty minutes, and I asked the Queen if she would remove the tiara. (I used the word "crown," which was a faux pas.) I suggested that a less dressy look might be better. And she said, "Less dressy! What do you think this is?" I thought she was being funny. English humor. But I noticed that the dresser and everyone else who had been working with her were staying about twenty feet away from her.

We removed the big robe, and I took the picture of the Queen looking out the window, and then I said, Listen, I was a little thrown when you first came in and I have one more picture I'd like to try, with the boat cloak. We went back into the anteroom where the gray canvas backdrop had been set up and she took off the tiara and put on the cloak. That's the shot we digitally imposed on pictures of the garden. The standing figure in the dress with the stole was also done against the gray backdrop and then put in the White Drawing Room. The real pictures of her in the drawing room are the ones where she's sitting. I forgot to shoot her standing there. I was nervous.

Right after we finished, I went up to the press secretary and said how much I loved the Queen. How feisty she was. Later I mentioned to a couple of friends that she had been a bit cranky, but it was nothing unusual. What was remarkable about the shoot, and I wrote the Queen a note about this later, was something the BBC missed: her resolve, her devotion to duty. She stayed until I said it was over. Until I said, "Thank you." We were finished a little before our allotted twenty-five minutes were up.

THE PROCESS

The first time I went on the road with a politician was in 1972, when I worked with Hunter Thompson during the Democratic primary. George McGovern won the nomination but lost the election to Richard Nixon by a landslide. I loved covering political stories then because politicians didn't have any sense of themselves. They were awkward. They were still putting shoe polish in their hair. It's much more controlled now.

The process has also changed. For a photojournalist, this means the change from film to digital. I noticed the first signs of this in 1994, when I was in Sarajevo during the siege. Photographers were still using film, but they were scanning their negatives and transmitting the files over satellite phone lines. By 1997, when I went on a trip to Africa with Hillary Clinton, digital cameras were available, although not many people had them. I think one person may have had a digital camera on that trip. It had been a while since I had been on the road by myself, and I was fumbling around and dropping rolls of film and getting the exposure wrong. I envied the guy with the digital camera. Hillary would come to the back of the bus and look at what he had taken. There were problems with digital, of course. It was hard to reconcile super light and super dark values. It's still not as good as film in that respect. But digital handles low-light situations much better.

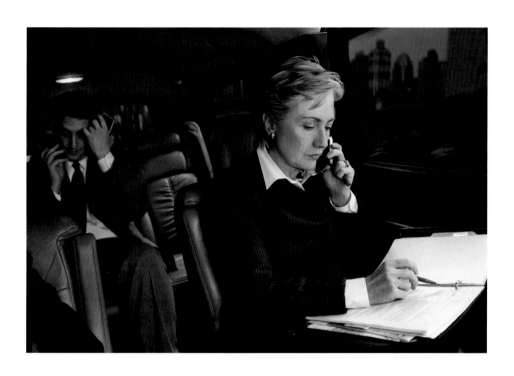

Hillary Clinton, New York City, 2003

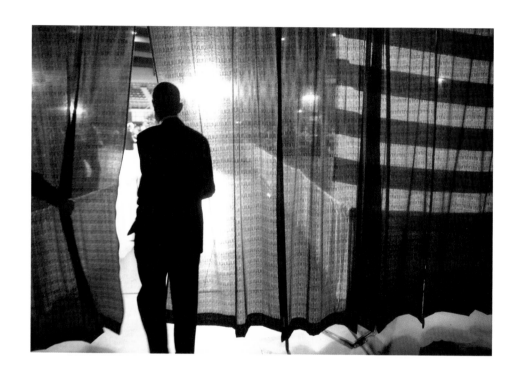

Barack Obama, Raleigh County Convention Center, Beckley, West Virginia, 2008

Now, for the way I work, it's possible to go out with one or two digital cameras and maybe a wide zoom lens and a mid-range zoom. I don't have to carry black-and-white and color film and high-speed film for inside and slower film for outside. Everything fits in a small backpack. When I traveled with Barack Obama during the primaries in 2008, the way the AP photographer operated fascinated me. His backpack was his office. As soon as we arrived at a site, someone from the campaign would set up a Wi-Fi system. The AP photographer would shoot the speech or whatever we were covering and before it was over he was back at the press table with his laptop, editing his pictures. He would transmit a few of them to the bureau and within ten or fifteen minutes they were on the wire. Speed was the thing. The first pictures sent out were the ones that were picked up.

I was shooting for a monthly magazine, so I had the luxury of looking at my pictures back at my studio and then going out again if I needed to. I found myself pulling back and photographing Obama's whole body. He's a very graceful man. Very elegant, with a little swagger. I had to do a portrait of him for a cover and I wanted him moving, maybe running for his plane. That didn't work out, so I did a portrait of him in the plane, working on a speech. I insisted on taking the picture when the plane was in the air. I wanted the backlight from the window. You don't get that blown-out backlight until you're up in the clouds, and it was important to me that the picture look natural. Up above the clouds is several stops brighter than sitting on the ground.

The first time I tried to take the cover picture we had a short hop between cities, and just as I was ready to go up front where Obama was sitting I was told that he had fallen asleep and they didn't want to wake him. I had to go home and do some other work, and a couple of weeks later I caught up with the campaign again and got on the plane and he fell asleep again. He had been putting in fourteen-hour days for months. It was the longest campaign in American history. Still. The third time I went out, I asked them if they really wanted to see me again. They made sure I got the picture.

Monument Valley, Arizona, 1993

THE ROAD WEST

I have a small but carefully selected collection of vintage photographs. Pictures that mean something to me. One of them is a black-and-white picture of a two-lane highway stretching through the center of the photograph until it disappears into a flat horizon. The highway was the route families took west, looking for work during the Depression. The picture was taken by Dorothea Lange in 1938 when she was traveling around the country for the Farm Security Administration. It makes me think of the story Lange told about one of her earliest field trips. After spending a month on the road in southern California she was finally heading home. It was raining and she was exhausted and she had a long drive ahead of her. She had been working up to fourteen hours a day for weeks and was bringing back hundreds of pictures of destitute farm workers. Somewhere south of San Luis Obispo she saw out of the corner of her eye a sign that said PEA-PICKERS CAMP. She tried to put it out of her mind. She had plenty of pictures of migrant farmers already. She was worried about her equipment, and thought about what might happen to her camera in the rain. She drove for about twenty miles past the sign and made a U-turn. She went back to the sign and turned down a muddy road. A woman was sitting with her children on the edge of a huge camp of makeshift

tents. There were maybe three thousand migrant workers living there. Lange took out her Graflex and shot six frames, one of them of the woman staring distractedly off to the side while two of her children buried their faces in her shoulders.

The image of the woman and her children became the most important photograph of Dorothea Lange's life and the iconic picture of the Depression.

When I'm asked about my work, I try to explain that there is no mystery involved. It is work. But things happen all the time that are unexpected, uncontrolled, unexplainable, even magical. The work prepares you for that moment. Suddenly the clouds roll in and the soft light you longed for appears.

Monument Valley, Arizona, 1993

EQUIPMENT
TEN MOST-ASKED QUESTIONS
PUBLISHING HISTORY
CHRONOLOGY

EQUIPMENT

Arnold Newman said that photography is one percent talent and ninety-nine percent moving furniture. I think about that sometimes when we're on location and we've moved the set—the stage, the lights, the backdrop, sandbags, fans. And moved them again. And again. I just have to close my eyes to everything that's being done. The manual labor is daunting.

It didn't start out that way. In the beginning, I traveled alone. I carried my equipment and if I used a light I would set it up myself. Some people took the results as a style. A writer for *American Photographer* once said that the umbrella and strobe reflected in the mirror in my portrait of Jimmy Carter was a "skillfully implemented device." As I recall, I walked into the room holding the light and set it down and plugged it in and started taking pictures. I didn't think about it.

I first worked with an assistant in 1975, during the Rolling Stones tour. I wanted to photograph the band together right after the show, when they were pumped up, and I had been talking to them about this for weeks. I told them how fantastic they looked all sweaty, but I could never get them to stop for the photograph. So one night in Los Angeles I hired an assistant who helped me hang a roll of seamless paper and set up a strobe outside the stage door. They had to walk across the paper to get to their cars. When they saw it they laughed and stopped and I got four or five frames.

If I borrowed someone's studio there would usually be an assistant there to help out, but I didn't start working regularly with my own assistants until I moved to New York, in 1977. I didn't hire someone full-time until I had my first studio, in 1981, and I found the new arrangement frustrating. The assistant didn't automatically see what I saw. Everyone sees things differently, and he often didn't know what to do even if he was standing next to me. I had watched Dick Avedon work and I didn't understand

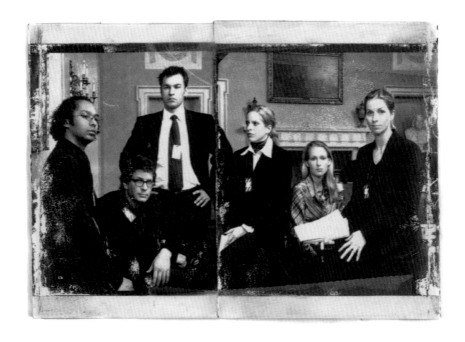

Paul Gilmore, Dennis Devoy, Henrick Olund, Karen Mulligan, Laura Crawford,
Kathryn MacLeod, Cabinet Room, the White House, Washington, D.C., December 2001

why it couldn't be like that. Avedon didn't have to tell his assistant where to move the light. It seemed to be done by osmosis. That came from working together for many years. Reluctantly, I had to learn to talk about the shoot before it happened, which didn't seem right. It took away the mystery.

The job description for an assistant is pretty loose. Over time, assistants have taken on roles I couldn't have envisioned when I started working. For instance, they have become indispensable as stand-ins for pre-lighting. It's a very important job. Nick Rogers, who has been my first assistant for many years; Kathryn MacLeod, the producer on *Vanity Fair* shoots; and the stylist Lori Goldstein were among the first people who did this for me. Pre-lighting with any stand-in is not ideal. Even if they are hired especially as body doubles, stand-ins don't have the same proportions as the subjects. Everyone's proportions are different. So you pre-light and think you have it right and then the subject walks in and you realize you don't. Nick was so good as a stand-in that after a while I didn't want to use him. He never looked bad, no matter what kind of light was on him.

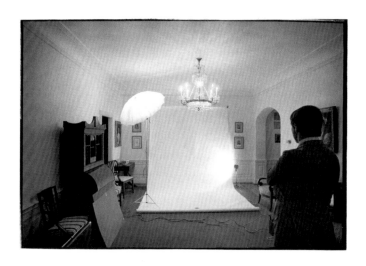

The White House, Washington, D.C, 1976

My assistants used to check out new equipment and work on lighting problems in the studio. Our last studio was in an old double garage in Chelsea. It was vast, with high ceilings. It was the studio of my dreams, but I realized I didn't need it. My best pictures are taken on location. Anyway, the studio got too big. We had a lot of equipment that wasn't necessary. Things were getting out of hand. Having a studio is a little like having a fancy car. It doesn't help you take better pictures. Now I have an office in a townhouse in the West Village. The assistants have a room where we keep just enough equipment for a small portrait shoot. There is an area for meetings. My studio manager and the archivists have spaces. Postproduction work on the pictures is done in a design room that has several computer stations. There are a number of fully-equipped photo studios in the neighborhood that we can rent. And we can set up a portable studio anywhere if we need to.

CAMERAS AND FILM My first camera was a Minolta SR-T 101. It came with a 55mm lens, which has a narrower depth of focus and angle of view than the 35mm lenses that many of the other students at the San Francisco Art Institute were using. I couldn't afford a new lens, so I worked with this lens for about a year. It was a good learning experience. You can be a little sloppy with a wide-angle lens. The 55mm made me very aware of what I was putting in the frame. It was good discipline in learning how to

see and compose. The 55mm had very little distortion. If I wanted a close-up picture I stepped up to the subject and if I wanted a wider shot I stepped back. After that first year, when I decided that I was serious about photography, I reluctantly sold the Minolta and got a Nikon F with a 35mm lens. The other students at the school were using a variety of cameras, but the most common were Nikons and Leicas.

I have always been a see-through-the-lens photographer. I use a single-lens reflex camera. With an SLR like the Minolta or the Nikon, you see precisely what image is going to be on the film. In a rangefinder camera, such as the Leica, you view and focus through a separate window rather than through the optical system of the lens. Once you start with an SLR, it's very hard to switch over to a rangefinder. If you're not careful with a rangefinder, it is easy to cut off some of the bottom of a picture and leave too much room at the top. I think that, at a certain point, some of the great photographers who had used Leicas for a long time, like Cartier-Bresson, didn't even look through the eyepiece to focus and frame. Susan Sontag told me that she didn't realize that Cartier-Bresson was taking her portrait when he was sitting across from her with his camera in his lap.

In the early days, *Rolling Stone* was printed on cheap paper in an 11" x 17" format and distributed folded over. The cover image was an 8½" x 11" vertical. It's very awkward to turn a 35mm camera like the Nikon on its side to shoot vertically. I'm convinced that there's even a distortion. The format of the magazine became squarer after 1978, and I decided to try a Hasselblad for the covers. All you had to do was cut off the sides of the picture a bit to create a cover for *Rolling Stone*. Most of the pictures for the inside of the magazine were still shot with a Nikon because the Hasselblad seemed a little too clear and unrealistically sharp. The bigger negative made for a handsomer image, but you couldn't convey the sense that you were simply in a room taking a picture. That it was not "photography." Combined with my over-lighting, the work got further and further away from natural. Most of the early conceptual pictures were taken with the Hasselblad.

In the seventies, I worked with a 24mm lens occasionally, and when I look at those pictures now they seem very much of the period and not very good. I call them my bell-bottom pictures. They're distorted. You could get pretty close to the subject with a 24mm lens, but when I used it in the seventies we didn't get that close. If I was working in a situation with a lot of other photographers, everyone was reasonably respectful.

People weren't standing in front of other people. By the eighties, however, when I was working for *Vanity Fair,* things had changed. I remember going to cover the trial of John Gotti, the mob boss, in New York. I took my little cameras down to the courthouse, and I discovered that the other photographers had lenses that were preposterously wide. The standard lens was 14mm to 24mm by then. Photographers would stand right next to the subject. If I stood back and took a picture with my regular lenses, I was getting the backs of the other photographers' heads. They were practically shoving their cameras in the subject's face. It was too cutthroat for me, and I didn't do many more of those kinds of stories.

In the mid-eighties, I began using a Mamiya RZ67, a medium-format camera that I handled in a rather unorthodox way. It was heavy and a little awkward to carry around, but I used it like a 35mm camera. The Mamiya was my principal camera until I began shooting with a digital camera. The only real problem I had with it was that it was hard to focus. But it was inevitable that a medium-format camera was going to be harder to focus than a 35mm. It wasn't just me who had the problem with focusing. I'd give the camera to my assistants to make some Polaroids or test the lighting and their pictures would always be out of focus. (That gave me a certain amount of pleasure, since assistants *love* to tell you that what you've done is out of focus.)

In the late eighties, when I went through my archives looking for pictures to put in the retrospective of my work from 1970–1990, I became nostalgic for the spontaneity of my early 35mm pictures. I had spent the previous few years working on covers and advertising and had put other kinds of work aside. I was doing mostly set-up pictures. I liked the set-up pictures, but I wanted to use a 35mm camera again. I tested all the 35mm cameras and decided to stick with Nikon. I liked their lenses, although none of the new lenses seemed as sharp as they used to be. And there seemed to be some drop in the quality of black-and-white film. Maybe it was simply the way they were processed, but, for whatever reason, my new prints didn't look like the old ones. There wasn't as much cadmium in the paper they were printed on. The paper wasn't as warm. I used a 35mm camera very rarely for assignments in the nineties, but I found myself experimenting with the Leica M6, a nice rangefinder camera with a winder that was constructed in such a way that I didn't have to pull my eye away from the camera body to use it. (I'm left-eyed, and cameras with manual winders are designed for right-eyed people. The advance lever is on the right side of the camera.) I began taking all my

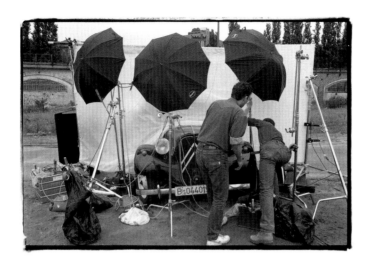

Berlin, 1992

personal pictures with the Leica. I carried it around in my bag. I photographed the death of my father with the Leica—35mm black and white.

When I began shooting digitally, I put a digital back on my Mamiya. This was not an ideal situation, since you couldn't use the full frame. And the camera body and back were awkward to handle. I felt clumsy. The recycle was very slow. I experimented with a 35mm digital camera, a Canon, when I photographed Mary J. Blige for the Gap and wanted to shoot her singing. There was going to be a lot of movement and I needed a camera with a fast recycle. When I looked at the files and realized that they were perfectly usable, I decided, What the heck, and stopped using the medium-format camera for the time being.

I enjoyed the sense of spontaneity I got from the 35mm digital camera, but after a while I missed the formality of the Mamiya's 140mm lens. It's a beautiful lens that I used to take some of my favorite pictures. The portrait of my mother taken for the *Women* book was made with that lens. And the portrait of Susan Sontag in my last sitting with her. And the picture of my daughter Sarah when she was six months old. It is a long lens, but you can make it feel a little wide if you want to. It is similar to the 55mm on the Minolta. It is graceful as a portrait lens. As I write, Mamiya is working on developing a feasible full-frame digital back. In an ideal world, I would have both: the 35mm and the medium-format Mamiya with that lens that I miss so much.

Walking Past Annie's Equipment, David Hockney, 1983

ADAPTATION Times change. For instance, manufacturers of film established what was accepted as "real" color, but the standards were arbitrary, and they evolved. In the early nineties I realized that the snapshots my mother was taking with Kodak Gold were more relaxed and spontaneous looking than the color transparencies I was working with. They were less stilted. I also admired the casual color of Nan Goldin's work, and I became convinced that I should move from transparencies to color negative. I explained this to the magazines I worked for, and they said absolutely not. The printers and art directors flipped out, but I told them they would just have to learn to live with it and learn how to print it. They were sitting in a room in an office and the photographers were out in the field dealing with changing conditions. We needed to have flexibility. It took some time for everyone to adjust, but color negative became the norm.

DIGITAL The problem I had with the digital process in the beginning was that it was a big production. There were suddenly a lot more people on a set. Technical people. In big shoots, like a cover shooting or a more set-up shooting, or advertising, there were two towers of equipment and an extra computer in case one of them went down. I was tethered to a machine, and things went wrong all the time. It was like working with a Ferrari. I got used to seeing the pictures on the monitor, and then everything shut down when the computer crashed. After a while, I realized that I was trying to do too much on the set. It simply wasn't necessary to make adjustments on the monitor while I was shooting. I decided to concentrate on taking pictures.

206

When I was working with film, I would start a shoot by taking Polaroids. When you saw in the Polaroids that you were getting what you were after, that the lighting was right and so on, you would start shooting film. That method was frustrating, of course, because the picture you wanted would inevitably be on the Polaroid and nowhere else, especially if movement was involved. Everything was building up to that, and you wanted to copy it. What's great now, digitally, is that you can keep the image that used to exist only on the Polaroid. So you shoot less. You get to see what you're doing. On some level you're editing as you go.

I believe that you are better able to capture what you really see in color with digital. There's a distinctive intensity in a digital file. Digital gives a more honest view of how things actually look, and with the advent of all these possibilities, I still want the pictures to look like they're real. Whatever camera helps me do that is the camera I'm going to use. I'm not nostalgic about cameras. When I talk about how important the camera is to me, I mean the idea of the camera. What photography does. I'm not into it because of the equipment, and I'm not concerned with the things that concern more technically acute people. I want to use whatever helps me take a picture in all kinds of light with faster speed and fewer problems. I changed my 35mm digital camera four times in one year. As soon as I hear there's a better one out, I try it.

LIGHTS Helmut Newton used to tell me that I should throw away my strobes. Helmut was a master of natural light. He was the only photographer I've known who could shoot in twelve-noon light. He used it to his advantage—those hard shadows, the contrast. He knew how to work with assistants and he could light if he needed to, but his best work was done simply. He usually traveled with just his cameras, and if he wanted an assistant he would hire someone local for the day. He thought that I was burdened down by the strobes. He was no doubt right to an extent, but I like to have a broad palette. I wanted to go into a shoot with a large vocabulary of ways to work.

Natural light is the greatest teacher. You place the strobe so that it follows the direction of the natural light. You try never to fight the natural light by coming from another direction. Adding strobe to the natural light outside makes a daylight studio. When you're working inside, you try to remember what natural light looks like and see if you can re-create it. I've never been able to make strobe light look as beautiful as natural light.

My key light is most often a single strobe. A single umbrella. I like the simplicity of that. The strobe emphasizes the direction of the light and illuminates the face. The rest of the picture can be lit with natural light. But you have to be prepared to use a back-up fill light. A light that usually comes from the direction of the camera.

The best time to do the kind of work I do is on an overcast day, or at the beginning or the end of the day. When the light levels are low. That's the time most photographers like to take pictures. The tones are most even then. Although I finally decided that shooting at sunset was too stressful. An assistant would be on the horizon with a meter monitoring f/stops and then suddenly we would be sitting in the dark. We had to walk out of the desert in total blackness once. There were scorpions and snakes and the guys didn't want to pick up any of the equipment. It's better to shoot at sunrise. After the sun comes over the hill you still have time to work.

Lighting outside meant carrying around my own sun. In the seventies, when I was working for *Rolling Stone,* I found the smallest strobe boxes that existed and a small case, about three feet long and a foot deep. The shelf on top held two lightweight Pic stands and two umbrellas. The lower shelf, which pulled out, had compartments that held a Norman 400 pack and two Norman heads. There was also room for a light meter. Some days you couldn't pick the case up. It was before anyone thought of putting wheels on cases. At first, I got power from weird transformers that I would plug into my car battery, which usually meant that at the end of the shoot the car wouldn't run. After a while I started traveling with generators and 2400- and 3200-watt-per-second Balcar packs because I thought I needed more power to match the natural light, especially on bright days. We would be on the beach with huge power packs and noisy generators. It started to be too much. The pictures were looking too formal and stagey and overlit. The subject was pretty much stuck where the lights were.

Ironically, advances in technology have made it possible for me to take Helmut Newton's advice about having too much equipment. With digital cameras, you're shooting at higher speeds and you use less light, so you don't need high-powered strobes. I've pared down the list of things we take on a shoot—our kit. I'm working now with battery-powered Profoto packs that weigh about ten pounds apiece. Since they don't have to be plugged in, I'm more mobile. I can go out with two battery packs and two small Profoto umbrellas. If I'm on a complicated shoot, or a cover shoot, I can rent more and bigger packs and lights.

26th Street Studio, New York City, 2000

LIGHT METERS A light meter is only a guide. It shouldn't be used literally. When I decided to tone down the strobe, we made it even with the natural light rather than being a stop over. Then we went a stop or two under the natural light. I liked the way things looked when they were barely lit. The darker pictures seemed refined, mysterious.

TRIPODS The tripod has always been part of a photographer's kit. You have to have one. I used to carry a Tilt-All, which was beautiful and simple. They made them in silver, but it was cool to have a black one. A beat-up black one. We still have one, although it's not good for a medium-format camera. The original tripod is my two legs. Being able to move, to go up and down, is an important part of my work. When the camera is put on a tripod, the picture looks different than when the camera is held in your hand. The photograph will never feel the same. My assistants will set up a tripod right next to me, and I won't use it. By the time you've renegotiated the tripod, you've lost the moment. Something's changed. I shoot a lot of pictures standing up. With a tripod, you have a tendency to straighten everything out. With your body, you unconsciously tilt yourself in. You're not coming straight on. You're fine tuning by pulling yourself in a little bit and then out a little bit.

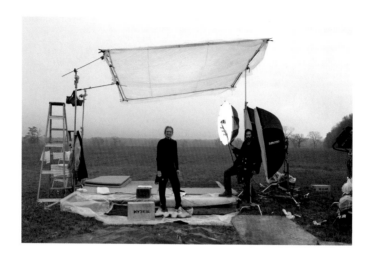

Annie with Nick Rogers, Houston, Texas, 2008

FANS There's a tendency to put a fan in one place and turn it on. If you have a big Ritter fan, which takes a truck to get in, you're creating a very big wind. Needless to say, the real wind doesn't work like that. I went to Cornwall once, to photograph the landscape where King Arthur was said to have had a castle. I was going to use it as a background for a portrait of Roger Federer as Arthur. We had a cape for him, and my first assistant, Nick Rogers, put the cape on to test it. It was late in the day, and we were on a bluff, and the cape moving in the wind was incredibly beautiful. The real wind doesn't come from just one side. When wind is constant, you blow the person away. What makes something look nice is intermittent movement and change of direction. My assistant Paul Gilmore is a master of the fan. When we photographed Julie Andrews as the Blue Fairy for Disney and we had to blow her dress up underneath her, we had four fans. We kept them all at very low levels. One was in the front, two were on either side, and one was at the back. All of them were going at different speeds.

MUSIC Bill King always had big fans running on his sets. The fans were a distraction. They focused attention on the process. I use music when I shoot. In the beginning it camouflaged my inability to talk to people. But the music on a shoot isn't just background. It raises the mood, sets a tone. The right music at the right time elevates the situation. Music can make or break a shoot.

TEN MOST-ASKED QUESTIONS

1. *What advice do you have for a young photographer who is just starting out?*

I've said about a million times that the best thing a young photographer can do is to stay close to home. Start with your friends and family, the people who will put up with you. Discover what it means to be close to your work, to be intimate with a subject. Measure the difference between that and working with someone you don't know as much about. Of course there are many good photographs that have nothing to do with staying close to home, and I guess what I'm really saying is that you should take pictures of something that has meaning for you. When I was a young photographer at *Rolling Stone*, I learned that what I did mattered. This may have been because I was published, but whether you're published or not, you have to care about what you do. You might even seem to be obsessive about it.

2. *What's your favorite photograph?*

I don't have a single favorite photograph. What means the most to me is the body of my work. The accumulation of photographs over the years.

3. *Who's the most difficult person you've ever photographed?*

The difficulties usually don't have much to do with the subject. What causes problems are things like the weather. It's too sunny or too dark. You haven't finished shooting and the sun is going down. If it's a big production, you might have a bad hair person. Bad makeup. The strobe doesn't fire fast enough, or doesn't fire at all. Those are real problems. But there certainly are people who are a pain to work with. I'd be crazy to name them. You can't be indiscreet in this business. That being said, in my experience the most difficult people are the people who have been in show business the longest.

ITEMS BORROWED:

1:
Title: Do like a duck does /
Item #: R0178611347
Due Date: 3/17/2011

2:
Title: Old Bear /
Item #: R0414749385
Due Date: 3/17/2011

3:
Title: Totally wonderful Miss Plumberry /
Item #: R0410080501
Due Date: 3/17/2011

4:
Title: Alfie's ABC /
Item #: R0128642534
Due Date: 3/17/2011

Especially those who have been in show business since they were children. Not all of them, of course, but some of them go off the edge. They've been catered to for so long that they have a very poor sense of reality.

4. *How many pictures do you take?*

Certainly fewer than I did when I was young. But I don't worry about it. It varies. It takes what it takes.

5. *Are you happy with the move from film to digital?*

I remember when Kodachrome II was phased out in the seventies. A lot of photographers bought cartons of it and stored it in their refrigerators. But the bottom line was that it was gone. Digital is here whether we like it or not. You can't fight it. In the beginning, I let the process take over. Productions were incredibly complicated. The rhythm of the shoot changed. I had to explain to the subject that I was going to go across the room to look at the picture on the monitor, which seemed a little rude. But now I don't usually have a monitor on the set, and if I do, I don't look at it very often. We just use a laptop, and I'm not tethered to it. I don't even look at the back of the camera very often. We're almost back to the rhythm of shooting with film.

You can photograph the night with digital. Darkness. I use much less light now. Less strobe. You can see more. The downside is that the pictures can look a little crude. There's almost too much information in them. It's a new language that needs to be translated, and I think that it is only going to improve. Think of early flash photography. Things were lit up in a harsh way in the beginning, and then we learned how to control the lights. Digital produces a look that seems appropriate for this moment in history. It's distinctive.

Digital was born for reportage. It's terrific for working spontaneously. I can go on the road with less equipment. I'm not carrying bags of film around. And I can shoot at unbelievably high speeds. We used to shoot at the lowest ASA possible, to avoid having grainy pictures. Higher speeds are rendering images much better than they used to.

6. *How is photographing a celebrity different from photographing a regular person?*

The fundamental difference is that you have a pretty good idea who the well-known person is when you meet them. They've been photographed before. You learn

a tremendous amount about a person from their visual history. This is useful, since famous people are almost always busy, and you have to be practical about how much time you're going to get with them. Photographing well-known people has built-in logistical problems. There are often quite a few other people with an interest in the outcome of the shoot. It's not always fulfilling work trying to meet the expectations magazines have about movie stars, for instance. It's not the movie stars themselves who create the difficulties. Most of them are fairly normal people.

7. *Where do you get your ideas?*

I do my homework. When I was preparing to photograph Carla Bruni, the new wife of Nicolas Sarkozy, the president of France, in the Élysée Palace, I looked at pictures of the palace. I looked at pictures of other people who had lived in the palace. Pictures of couples in love. Pictures that other photographers had taken of Bruni. She had been photographed many times before. I thought Helmut Newton had seen something in her that other photographers hadn't. I knew she was a popular musician, and I listened to her music.

Of course I carry around with me, like a backup hard drive in my head, a vast memory bank of the work of the photographers who came before me. I'm a fan of photography. A student, if you will. I collect photography books. Something in the history of photography might contribute to the style I choose to shoot in. The style of the photograph is part of the idea.

8. *When do you know you have a good picture?*

When I was young, I never knew when to stop. I could never tell what I had. I was afraid I was going to miss something if I left. I remember working with the writer David Felton on a story about the Beach Boys and being surprised that at a certain point he just walked away. He said he had enough material, which seemed incomprehensible to me. What did he mean he had enough? How could he even think like that? I thought that if you kept doing it, it would get better and better.

As I became more experienced, I began to understand that someone who is being photographed can work for only so long and that you shouldn't belabor the situation. Something is either going to happen or it's not going to happen. It's not going to suddenly turn into something else. Or very rarely. What does happen a lot is that as

soon as you say it's over, the subject will feel relieved and suddenly look great. And then you keep shooting.

There are times when I just *can't* get what I want. I sometimes think I get maybe ten percent of what I see. I can be very frustrated, for instance, by natural light. Sometimes the light on someone looks incredibly beautiful but it just won't translate into the photograph. It won't look the same. Photography is limited. It's an illustration of what's going on. Basically, you're never totally satisfied.

9. *How much direction do you give?*

A lot of the direction of the shoot takes place before the subject comes in. This is certainly the case with set-up portraits. By the time the subject arrives we've figured out what is possible for them to do. You set the stage for them. Once they are there, they like to have some direction. They like to be at least told that they're doing all right. I forget about that from time to time.

A lot of my work is post-decisive-moment. It's studied. A kind of performance art. It would be nice to be more spontaneous, but circumstances don't always allow that. There is often a limited amount of working time, and certain goals. Nevertheless, as prepared as you are for one thing, you hope that something else will happen too.

10. *How do you set people at ease and get them to do the things that they do in your pictures?*

I never set anyone at ease. I always thought it was their problem. Either they were at ease or they weren't. That was part of what was interesting about a picture. Setting people at ease is not part of what I do. The question assumes that one is looking for a "nice" picture, but a good portrait photographer is looking for something else. It might be a nice picture and it might not. I know, however, that I do set people at ease because I'm very direct. I'm there simply to take the picture and that's it.

Most people don't like having their picture taken. It's a stressful, self-confrontational moment. Some people are better at it than others. I work best with people who can project themselves, but many people can't do that. Or they don't want to. They don't feel good about themselves. Or they feel too good about themselves. I'm not very accomplished at talking to people, and I certainly can't talk to people and take pictures at the same time. For one thing, I look through a viewfinder when I work. Richard

Avedon seduced his subjects with conversation. He had a Rolleiflex that he would look down at and then up from. It was never in front of his face. Most of the great portrait photographers didn't have a camera in front of their faces. It was next to them while they talked.

The classic anecdote about Avedon getting what he wanted from a sitter is the one about him going to photograph the Duke and Duchess of Windsor. They were great animal lovers. They doted on their pugs. Avedon set up the portrait, talking all the while, and just before he took the picture he told them a story, completely untrue, about how on the way to the sitting his taxi had run over a little dog. That broke their composure. He got the famous portrait of them looking anguished.

Maybe if I live another fifty years I could do that. You have to admire it, though.

I think the only form of seduction I'm capable of is the assurance that I'm a good photographer and that we're going to do something interesting. I've never asked anyone to do something that didn't seem right for them. And I don't ask them to do something for no reason. There's always some thought behind my pictures. I throw out several ideas and see what the subject wants to do. When I photographed the performance artist Rachel Rosenthal, for instance, I gave her three or four ideas. The last one was about being buried in the sand in the desert. That's the one she got excited about. I also sometimes ask a subject if they have ideas. The portrait of Cindy Sherman was her idea. I just brought it to life. Realized it.

It's a collaboration. Especially if you're working with an entertainer, an actor or a comedian. I never *make* people do anything. But I'm the photographer. It's a photo session. A lot of it is about play. Painting the Blues Brothers blue, for instance. Or giving a subject a role, a fantasy, to act out. I'm interested in getting something unpredictable, something you don't normally see. Even so, when the picture starts to happen, it's often a surprise.

PUBLISHING HISTORY

In 1977, when Jann Wenner asked me to prepare a fifty-page portfolio of pictures for the tenth-anniversary issue of *Rolling Stone,* I decided not to simply make a selection of photographs that had run in the magazine. I looked at everything I had done since I started working. It was a revelation. For one thing, I had no idea that I had accumulated so many photographs. You lose track of them when you're working every day. And you see the work in a different way when you look at it from the distance of time. You get a sense of where you are going. You start to see a life. Looking at the body of work gave me the impetus to go on.

I had a chance to edit my work most thoroughly when I prepared the books *Annie Leibovitz: 1970–1990* and *A Photographer's Life: 1990–2005.* It was thrilling to see that first book laid out chronologically. To see the pictures historically. The second book, *A Photographer's Life,* was assembled immediately after the death of Susan Sontag and my father. Editing the book took me through the grieving process.

The books are pure. They are mine. The magazines don't belong to me. It's the editor's magazine, and the editor has every right to use the material the way he or she wants to. It isn't just that art directors and editors at magazines make selections that I wouldn't necessarily make. Which they sometimes do. Or that they run pictures too small. Which they used to do. Or that they put so much type on the pictures that you can't see them anymore. Magazines have quite specific needs. It's a collaboration only so far, which is true of almost all assignment work.

The following section illustrates how and where the pictures first appeared. An asterisk indicates that a picture was published originally in an alternate version.

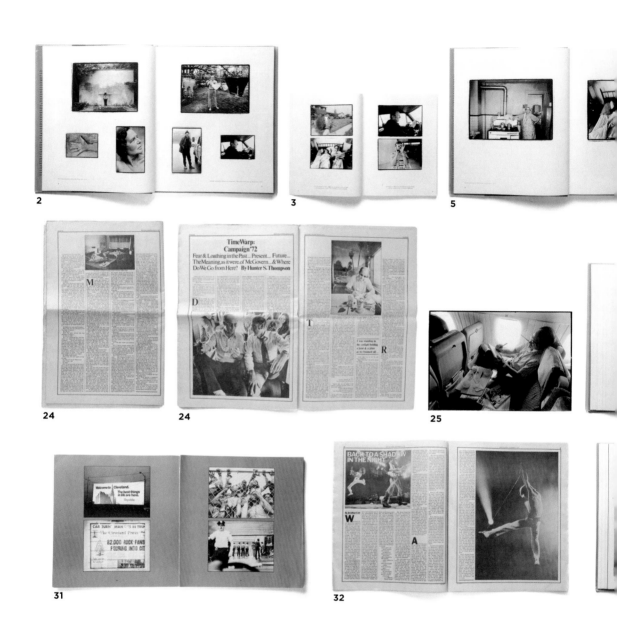

2 Samuel Leibovitz Silver Spring, Maryland, 1972, *Annie Leibovitz: 1970–1990*, Nikon F, Kodak Tri-X 400 **3** Marilyn Leibovitz Dulles International Airport, Virginia, 1972, *Annie Leibovitz: 1995*, Nikon F, Kodak Tri-X 400 **5** Rachel Leibovitz Waterbury, Connecticut, 1974, *Annie Leibovitz: 1970–1990*, Nikon F, Kodak Tri-X 400 **10** Self-portrait San Francisco, 1970, unpublished, Nikon F, Kodak Tri-X 400 **15** Golden Gate Bridge San Francisco, 1977, unpublished, Nikon F, Kodak Tri-X 400 **21** Richard Nixon leaving the White House Washington, D.C., 1974, *Rolling Stone*, September 12, 1974, Editor: Jann Wenner, Art Director: Tony Lane, Nikon F, Kodak Tri-X 400 **24** Hunter S. Thompson Washington, D.C., 1972, *Rolling Stone*, July 5, 1973*, Editor: Jann Wenner, Art Director: Robert Kingsbury, Nikon F, Kodak Tri-X 400 **24** Hunter S. Thompson and George McGovern San Francisco, 1972, *Rolling Stone*, July 5, 1973*, Editor: Jann Wenner, Art Director: Robert Kingsbury, Nikon F, Kodak Tri-X 400 **25** Hunter

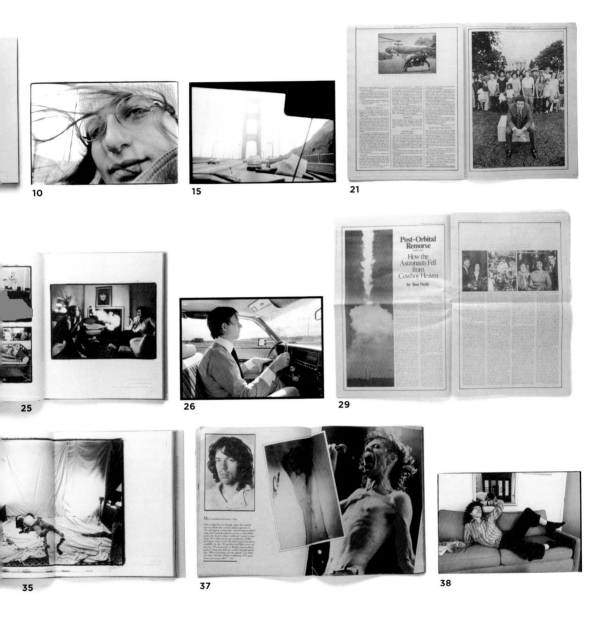

10 S. Thompson California, 1972, unpublished, Nikon F, Kodak Tri-X 400 **25** Hunter S. Thompson and Jann Wenner New York City, 1976, *Annie Leibovitz: 1970–1990*, Nikon F, Kodak Tri-X 400 **26** Tom Wolfe Florida, 1972, unpublished, Nikon F, Kodak Tri-X 400 **29** *Apollo 17* Cape Kennedy, Florida, 1972, *Rolling Stone*, January 18, 1973, Editor: Jann Wenner, Art Director: Robert Kingsbury, Nikon F, Kodak Tri-X 400 **31** Rolling Stones fans Cleveland, Ohio, 1975, *The Rolling Stones on Tour* (1978)*, Nikon F, Kodak Tri-X 400 **32** The Rolling Stones Philadelphia, 1975, *Rolling Stone*, September 11, 1975, Editor: Jann Wenner, Art Director: Tony Lane, Nikon F, Kodak Tri-X 400 **35** Keith Richards Toronto, 1977, *Annie Leibovitz: 1970–1990*, Nikon F, Kodak Tri-X 400 **37** Mick Jagger Chicago, 1975, *Rolling Stone*, December 15, 1977, Editor: Jann Wenner, Art Director: Roger Black, Designer: Bea Feitler, Nikon F, Kodak Ektachrome 64 EPR **38** Mick Jagger San Francisco, 1975, unpublished, Nikon F, Kodak Tri-X 400

38 Keith Richards with his son Toronto, 1977, *Annie Leibovitz: 1970–1990,* Nikon F, Kodak Tri-X 400 **39** Ron Wood and Keith Richards Jacksonville, Florida, 1975, *Annie Leibovitz: 1970–1990,* Nikon F, Kodak Tri-X 400 **39** Mick Jagger, Andy Warhol, and Fred Hughes Montauk, New York, 1975, *The Rolling Stones on Tour* (1978), Nikon F, Kodak Tri-X 400 **40** Bianca Jagger, Earl McGrath, and Ahmet Ertegun New York, 1972, *Rolling Stone,* August 31, 1972, Editor: Jann Wenner, Art Director: Robert Kingsbury, Nikon F, Kodak Tri-X 400 **40** Andy Warhol, Lee Radziwill, Truman Capote, and Vincent Fremont New York City, 1972, *Rolling Stone,* August 31, 1972, Editor: Jann Wenner, Art Director: Robert Kingsbury, Nikon F, Kodak Tri-X 400 **41** Andy Warhol, Truman Capote, Danny Seymour, and Robert Frank New Orleans, 1972, *Annie Leibovitz: 1970–1990,* Nikon F, Kodak Tri-X 400 **41** Keith Richards Buffalo, New York, 1975, *The Rolling Stones on Tour* (1978), Nikon F, Kodak Tri-X 400 **43** Mick Jagger Buffalo, New York, 1975, *Annie Leibovitz: 1970–1990,* Nikon F, Kodak Tri-X 400 **45** John Lennon New York City, 1970, *Rolling Stone,* January 21, 1971, Editor: Jann Wenner, Art Director: Robert Kingsbury, Nikon F, Kodak Tri-X 400 **47** John Lennon and Yoko Ono New York City, December 8, 1980, *Rolling Stone,* January 22, 1981, Editor: Jann Wenner, Art Director: Mary Shanahan, Design Director: Bea Feitler, Hasselblad 500 C/M, Kodak Ektachrome 64 EPR **50** Tess Gallagher Syracuse, New York, 1980, *Life,* April 1981*,

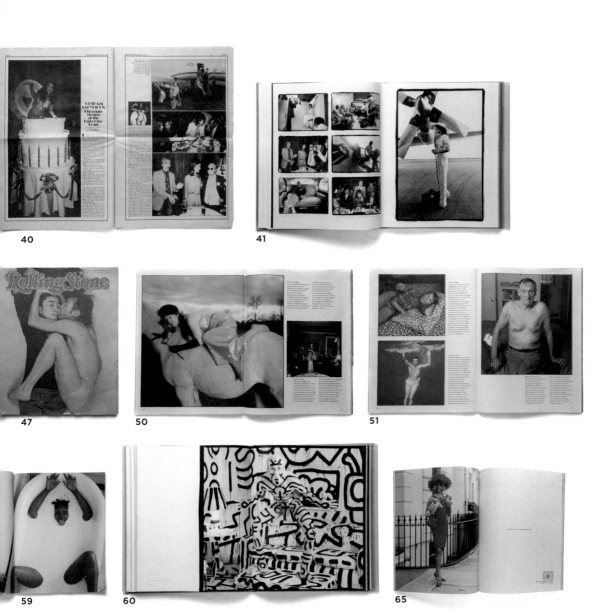

40

41

47

50

51

59

60

65

Managing Editor: Philip B. Kunhardt, Jr., Art Director: Bob Ciano, Hasselblad 500 C/M, Kodak Ektachrome 64 EPR **51** ROBERT PENN WARREN Fairfield, Connecticut, 1980, *Life,* April 1981, Managing Editor: Philip B. Kunhardt, Jr., Art Director: Bob Ciano, Hasselblad 500 C/M, Kodak Ektachrome 64 EPR **53** BETTE MIDLER New York City, 1979, *Rolling Stone,* December 13, 1979*, Editor: Jann Wenner, Art Director: Mary Shanahan, Hasselblad 500 C/M, Kodak Ektachrome 64 EPR **54** MERYL STREEP New York City, 1981, *Rolling Stone,* October 15, 1981, Editor: Jann Wenner, Art Director: Mary Shanahan, Design Director: Bea Feitler, Hasselblad 500 C/M, Kodak Ektachrome 64 EPR **56** THE BLUES BROTHERS Hollywood, 1979, *Rolling Stone,* February 22, 1979, Editor: Jann Wenner, Art Director: Mary Shanahan, Hasselblad 500 C/M, Kodak Ektachrome 64 EPR **57** STEVE MARTIN Beverly Hills, 1981, *Rolling Stone,* February 18, 1982*, Editor: Jann Wenner, Art Director: Mary Shanahan, Hasselblad 500 C/M, Kodak Ektachrome 64 EPR **59** WHOOPI GOLDBERG Berkeley, California, 1984, *Vanity Fair,* July 1984, Editor: Tina Brown, Design Director: Ruth Ansel, Hasselblad 500 C/M, Kodak Ektachrome 64 EPR **60** KEITH HARING New York City, 1986, unpublished photograph for *Splash,* Editor: Charles Jordan Crandall, Art Director: Marilyn Taylor Ponzo, *Annie Leibovitz: 1970–1990,* Mamiya RZ67, Kodak Ektachrome 64 EPR **65** JOHN CLEESE London, 1990, American Express*, Mamiya RZ67, Kodak Ektachrome 64 EPR

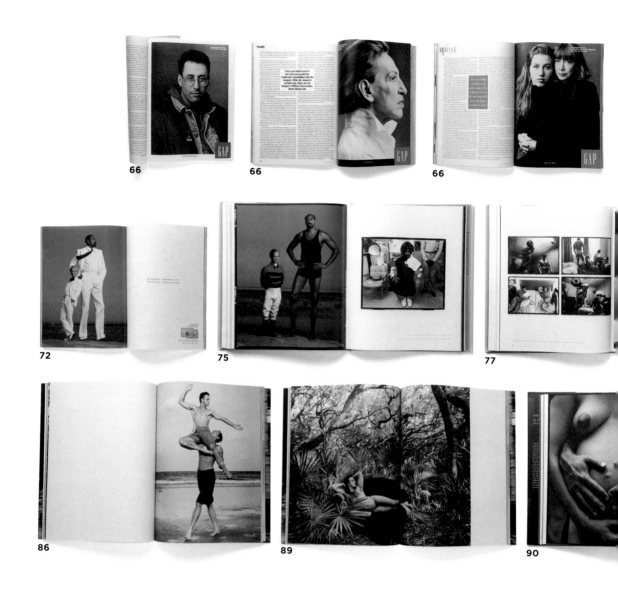

66 Tony Kushner New York City, 1992, Gap*, Mamiya RZ67, Polaroid 665 80 66 Andrée Putman New York City, 1989, Gap, Mamiya RZ67, Polaroid 665 80 66 Joan Didion and Quintana Roo Dunne New York City, 1989, Gap, Mamiya RZ67, Kodak Plus-X 125 66 William Wegman and Fay Ray New York City, 1988, Gap*, Mamiya RZ67, Kodak Plus-X 125 68 Evander Holyfield New York City, 1992, Gap, Mamiya RZ67, Kodak Plus-X 125 71 Ella Fitzgerald Beverly Hills, 1988, American Express*, Mamiya RZ67, Kodak Ektachrome 64 EPR 72 Willie Shoemaker and Wilt Chamberlain Malibu, California, 1987, American Express*, Mamiya RZ67, Kodak Ektachrome 64 EPR 75 Al Sharpton PrimaDonna Beauty Care Center, Brooklyn, New York, 1988, *Annie Leibovitz: 1970–1990,* Mamiya RZ67, Kodak Plus-X 125 77 Arnold Schwarzenegger Pretoria, South Africa, 1975, *Annie Leibovitz: 1970–1990,* Nikon F, Kodak Ektachrome 64 EPR 78 Arnold Schwarzenegger Pretoria, South Africa, 1975, *Rolling Stone,* June 3, 1976*, Nikon F, Kodak Tri-X 400 81 Arnold Schwarzenegger Malibu, California, 1988, *Vanity Fair,* June 1990*, Editor: Tina Brown, Art Director: Charles

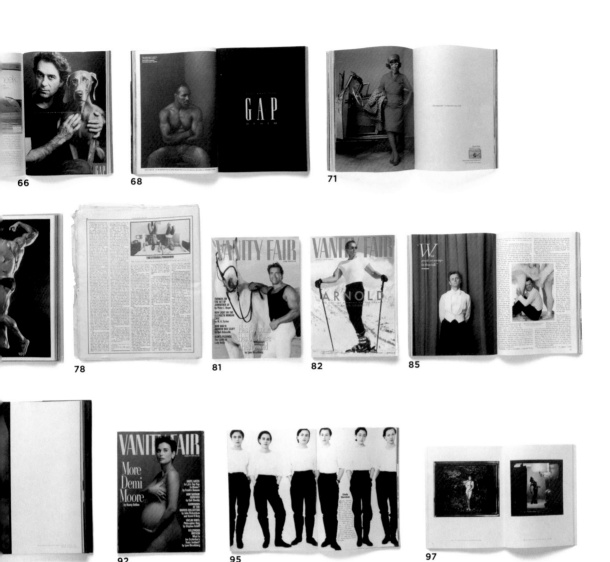

66

68

71

78

81

82

85

92

95

97

Churchward, Mamiya RZ67, Kodak Tri-X 320 **82** ARNOLD SCHWARZENEGGER Sun Valley, Idaho, 1997, *Vanity Fair,* June 1997, Editor: Graydon Carter, Art Director: David Harris, Mamiya RZ67, Kodak Vericolor III **85** MIKHAIL BARYSHNIKOV New York City, 1989, *Vanity Fair,* November, 1989, Editor: Tina Brown, Art Director: Charles Churchward, Mamiya RZ67, Kodak Ektachrome 64 EPR **86** MIKHAIL BARYSHNIKOV AND ROB BESSERER Cumberland Island, Georgia, 1990, *The White Oak Dance Project,* Mamiya 645, Kodak Plus-X 125 **89** MARK MORRIS Cumberland Island, Georgia, 1990, *The White Oak Dance Project,* Mamiya RZ67, Kodak Plus-X 125 **90** BRUCE WILLIS AND DEMI MOORE Paducah, Kentucky, 1988, *A Photographer's Life,* Mamiya RZ67, Polaroid 665 80 **92** DEMI MOORE Culver City, California, 1991, *Vanity Fair,* August 1991, Editor: Tina Brown, Art Director: Charles Churchward, Mamiya RZ67, Kodak Ektachrome 64 EPR **95** CINDY SHERMAN New York City, 1992, *Vanity Fair,* April 1992, Editor: Tina Brown, Art Director: Charles Churchward, Mamiya RZ67, Polaroid 665 80 **97** LEIGH BOWERY New York City, 1993, *Annie Leibovitz: 1995,* Mamiya RZ67, Polaroid 665 80

225

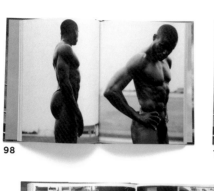

98

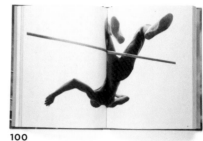

100

103

108

109

109

115

118

118

119

98 Carl Lewis Pearland, Texas, 1996, *Olympic Portraits,* Mamiya RZ67, Polaroid 665 80 **100** Charles Austin Atlanta, Georgia, 1996, *Olympic Portraits,* Fuji 6x9, Kodak Tri-X 400 **103** Bloody bicycle Sarajevo, 1993, *Annie Leibovitz: 1995,* Contax, Kodak T-Max P3200 **104** Dr. Sanja Besarović Koševo Hospital, Sarajevo, 1993, *Vanity Fair,* October 1993, Editor: Graydon Carter, Art Director: Charles Churchward, Contax, Kodak T-Max P3200 **104** Classroom Sarajevo, 1993, *Vanity Fair,* October 1993, Editor: Graydon Carter, Art Director: Charles Churchward, Contax, Kodak Tri-X 320 **105** Ćelo Sarajevo, 1993, *Vanity Fair,* October 1993, Editor: Graydon Carter, Art Director: Charles Churchward, Fuji 6x9, Kodak Tri-X 320 **105** Haris Pašović, Susan Sontag, and Zdravko Grebo Sarajevo, 1993, *A Photographer's Life,* Contax, Kodak T-Max P3200 **108** Nedžad Ibrišimović and his grandson Sarajevo, 1993, *Vanity Fair,* October 1993, Editor: Graydon Carter, Art Director: Charles Churchward, Contax, Kodak Tri-X 320 **108** Hasan Gluhić Sarajevo, 1993, *A Photographer's Life,* Contax, Kodak T-Max P3200 **109** Soccer field Sarajevo, 1993, unpublished, Fuji 6x9,

226

Kodak Tri-X 320 **109** Kemal Kurspahić, Gordana Knežević, and Zlatko Dizdarević Sarajevo, 1993, unpublished, Contax, Kodak Tri-X 400 **111** Rwanda 1994, *Vanity Fair,* December 1994, Editor: Graydon Carter, Art Director: Charles Churchward, Nikon F, Fuji NHG 400 **112** O. J. Simpson Los Angeles Criminal Courts Building, 1995, *The New Yorker,* April 1, 1995, Editor: Tina Brown, Art Director: Caroline Mailhot, Nikon F, Kodak T-Max P3200 **114** Little girl Brentwood, 1995, *Stern* Portfolio, 1997*, Nikon F, Kodak Tri-X 400 **114** Man with black cap Brentwood, 1995, *Stern* Portfolio, 1997, Nikon F, Kodak Tri-X 400 **115** Dog Brentwood, 1995, unpublished, Nikon F, Kodak Tri-X 400 **115** Two men Brentwood, 1995, *Stern* Portfolio, 1997, Nikon F, Kodak Tri-X 400 **118–119** Criminal Courts Building 1995, unpublished, Nikon F, Kodak Tri-X 400 **120** Tony Curtis and Jack Lemmon Los Angeles, 1995, *Vanity Fair,* April 1995, Editor: Graydon Carter, Art Director: David Harris, Mamiya RZ67, Fuji Reala 100 **123** Patti Smith New Orleans, 1978, *Rolling Stone,* July 27, 1978, Editor: Jann Wenner, Art Director: Roger Black, Nikon F, Ektachrome 64 EPR

227

124 126 128

137 138 139

124 PATTI SMITH New York City, 1996, *Women,* Mamiya RZ67, Kodak Plus-X 125 126 PUFF DADDY AND KATE MOSS Paris, 1999, *Vogue,* October 1999, Editor: Anna Wintour, Art Director: Charles Churchward, Fashion Editor: Grace Coddington, Mamiya RZ67, Kodak Portra 160NC 128 BEN STILLER Paris, 2001, *Vogue,* October 2001, Editor: Anna Wintour, Art Director: Charles Churchward, Fashion Editor: Grace Coddington, Mamiya RZ67, Kodak Portra 160NC 130 NATALIA VODIANOVA, STEPHEN JONES, AND CHRISTIAN LACROIX Paris, 2003, *Vogue,* December 2003, Editor: Anna Wintour, Art Director: Charles Churchward, Fashion Editor: Grace Coddington, Mamiya RZ67, Kodak Portra 160NC 133 KEIRA KNIGHTLEY AND JEFF KOONS Goshen, New York, 2005, *Vogue,* December 2005, Editor: Anna Wintour, Art Director: Charles Churchward, Fashion Editor: Grace Coddington, Mamiya RZ67, Kodak Portra 160NC 134 KIRSTEN DUNST Versailles, 2006, *Vogue,* September 2006, Editor: Anna Wintour, Art Director: Charles Churchward, Fashion Editor: Grace Coddington, Canon EOS-1Ds Mark II 137 LAUREN GRANT White Oak Plantation, Florida, 1999, 2000 Pirelli calendar, Mamiya RZ67, Kodak Vericolor III 138 JUNE OMURA

130

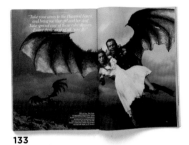

133

134

143

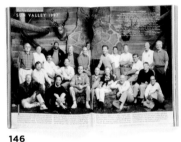

146

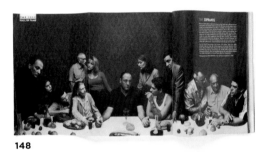

148

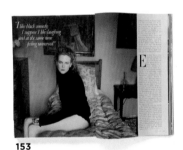

153

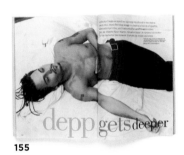

155

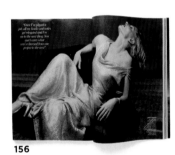

156

Rhinebeck, New York, 1999, 2000 Pirelli calendar, Mamiya RZ67, Kodak Vericolor III **139** JUNE OMURA Rhinebeck, New York, 1999, 2000 Pirelli calendar, Mamiya RZ67, Kodak Vericolor III **143** THE BUSH ADMINISTRATION The White House, Washington, D.C., December 2001, *Vanity Fair,* February 2002, Editor: Graydon Carter, Art Director: David Harris, Mamiya RZ67, Kodak Portra 160NC **146** SUN VALLEY CONFERENCE Sun Valley, Idaho, 1997, *Vanity Fair,* October 1997, Editor: Graydon Carter, Art Director: David Harris, Mamiya RZ67, Polaroid 665 80 **148** THE SOPRANOS New York City, 1999, *Vanity Fair,* December 1999, Editor: Graydon Carter, Art Director: David Harris, Mamiya RZ67, Kodak Portra 160NC **153** NICOLE KIDMAN East Sussex, England, 1997, *Vanity Fair,* October 1997, Editor: Graydon Carter, Art Director: David Harris, Fuji 6x9, Kodak Vericolor III **155** JOHNNY DEPP New York City, 1994, *Vogue,* September 1994, Editor: Anna Wintour, Art Director: Raúl Martinez, Mamiya RZ67, Kodak Plus-X 125 **156** CATE BLANCHETT Los Angeles, 2004, *Vogue,* December 2004*, Editor: Anna Wintour, Creative Director: Grace Coddington, Art Director: Charles Churchward, Mamiya RZ67, Kodak Portra 160 NC

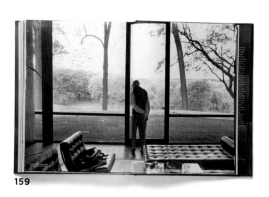

159

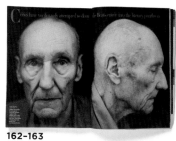

162–163

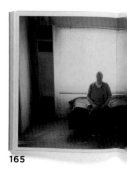

165

170

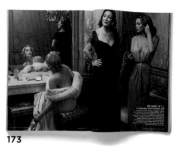

173

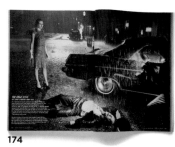

174

176

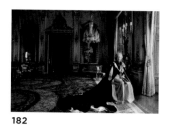

182

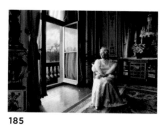

185

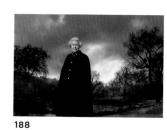

188

191

159 Philip Johnson New Canaan, Connecticut, 2000, *A Photographer's Life,* Leica, Kodak Tri-X 400 **162–163** William S. Burroughs Lawrence, Kansas, 1995, *Vanity Fair,* December, 1995, Editor: Graydon Carter, Art Director: David Harris, Mamiya RZ67, Polaroid 665 80 **165** Agnes Martin Taos, New Mexico, 1999, *Women,* Leica M6, Kodak 400 PMC **167** Marilyn Leibovitz Clifton Point, New York, 1997, *Women,* Mamiya RZ67, Polaroid 665 80 **169** Sarah Cameron Leibovitz New York City, 2002, *A Photographer's Life,* RZ67, Kodak Portra 160NC **170** Susan Sontag Paris, 2003, jacket photo, *Regarding the Pain of Others**, Mamiya RZ67, Polaroid 665 80 **173** Sharon Stone, Anjelica Huston, and Diane Lane Los Angeles, 2006, *Vanity Fair,* March 2007, Editor: Graydon Carter, Art Director: David Harris, Fashion Editor: Michael Roberts, Canon EOS-1Ds Mark II **174** Kirsten Dunst, Bruce Willis, and James McAvoy Los Angeles, 2006, *Vanity Fair,* March 2007, Editor: Graydon Carter, Art Director: David Harris, Fashion Editor: Michael Roberts, Canon EOS-1Ds Mark II **176** Judi Dench and Helen Mirren Los Angeles, 2006, *Vanity Fair,* March 2007, Editor: Graydon

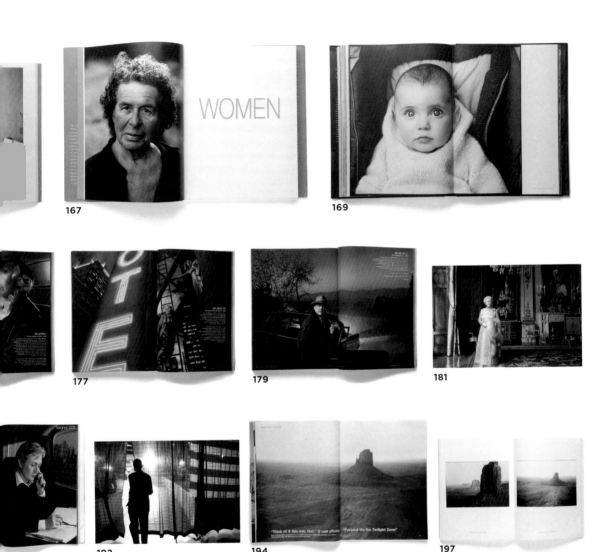

Carter, Art Director: David Harris, Fashion Editor: Michael Roberts, Canon EOS-1Ds Mark II **177** Helen Mirren and Kate Winslet New York City, 2006, *Vanity Fair,* March 2007, Editor: Graydon Carter, Art Director: David Harris, Fashion Editor: Michael Roberts, Canon EOS-1Ds Mark II **179** Jack Nicholson Los Angeles, 2006, *Vanity Fair,* March 2007, Editor: Graydon Carter, Art Director: David Harris, Fashion Editor: Michael Roberts, Canon EOS-1Ds Mark II **181–188** Elizabeth II London, March 28, 2007, published in various media, Canon EOS-1Ds Mark II **191** Hillary Clinton New York City, 2003, *Vogue,* December 2003, Editor: Anna Wintour, Art Director: Charles Churchward, Hasselblad H1 645, Kodak Portra 160NC **192** Barack Obama Beckley, West Virginia, 2008, *Men's Vogue,* October 2008, Editorial Director: Anna Wintour, Editor: Jay Fielden, Art Director: Courtney Sava, Canon EOS-1Ds Mark II **194** Monument Valley Arizona, 1993, *Condé Nast Traveler,* October 1993, Editor: Thomas J. Wallace, Design Director: Diana La Guardia, Fuji 6x9, Kodak Tri-X 400 **197** Monument Valley Arizona, 1993, *Annie Leibovitz: 1995,* Fuji 6x9, Kodak Tri-X 400

ANNIE LEIBOVITZ CHRONOLOGY

1949 October 2. Born in Waterbury, Connecticut, the third of Samuel and Marilyn Leibovitz's six children. Samuel Leibovitz is a career Air Force officer, and the family lives on or near several different military bases during her childhood.

1967 Starts freshman year as a painting student at the San Francisco Art Institute.

1968 Spends summer with family at Clark Air Base in the Philippines. Buys first camera, a Minolta SR-T 101, in Japan. Starts sophomore year at the San Francisco Art Institute (SFAI). Takes night class in photography.

1969 Takes summer photography workshop at the San Francisco Art Institute. In the fall, travels to Israel, where she lives in Kibbutz Amir. Misses fall semester.

1970 In January, goes back to the San Francisco Art Institute. Begins printing material from Israel. Takes photographs of antiwar rallies in San Francisco and Berkeley. One of her pictures of a demonstration appears on the June 11 cover of *Rolling Stone*. In the fall, starts senior year at SFAI. In December, travels to New York to photograph John Lennon, who is being interviewed by Jann Wenner.

1971 Portrait of John Lennon appears on January 21 cover of *Rolling Stone*. Receives a Bachelor of Fine Arts from the San Francisco Art Institute.

1972 Covers the presidential election campaign with Hunter S. Thompson.

1973 Listed as "chief photographer" on masthead of May 10 issue of *Rolling Stone*.

1974 Photographs of Nixon's resignation appear in *Rolling Stone's* September 12 issue. *The Photojournalist: Mary Ellen Mark and Annie Leibovitz* is published in Larry Schiller's Masters of Contemporary Photography series (Alskog/Crowell).

1975 Works as tour photographer for the Rolling Stones.

1977 *Rolling Stone* offices move to New York. A portfolio of her work, designed by Bea Feitler, appears in the tenth-anniversary issue of the magazine.

1980 Photographs John Lennon and Yoko Ono the day Lennon is murdered.

1981 Commissioned to take portraits for the prototype of the revived *Vanity Fair* magazine, designed by Bea Feitler. Establishes first studio, at 101 West 18th Street in Manhattan.

1983 Resigns from *Rolling Stone* in January. In April, becomes first contributing photographer for the new *Vanity Fair*. Publishes *Annie Leibovitz: Photographs* (Pantheon). Exhibition at the Sidney Janis Gallery in New York subsequently travels to Chicago; Atlanta; Dallas; Washington, D.C.; San Francisco; Los Angeles; and venues in Europe.

1984 Receives Photographer of the Year Award from the American Society of Magazine Photographers.

1985 Accepts commission as official portrait photographer for the World Cup Games in Mexico.

1986 Second solo show at the Sidney Janis Gallery.

1987 Commissioned by American Express to create images for the Portraits advertising campaign. Receives the American Society of Magazine Photographers' award for Innovation in Photography.

1988 Meets Susan Sontag. Commissioned by the Gap to create portraits for the Individuals of Styles ad campaign. Receives CLIO award for American Express Portraits campaign.

1989 *American Ballet Theatre, the First Fifty Years: Portraits by Annie Leibovitz* published. Receives CLIO award for Gap Individuals of Style campaign. Moves into new studio at 55 Vandam Street.

1990 Invited by Mark Morris and Mikhail Baryshnikov to document the formation of the White Oak Dance Project. *The White Oak Dance Project: 1990–1991 American Tour* published. Exhibition of photographs at the James Danziger Gallery in New York. Receives Infinity Award in Applied Photography from the International Center of Photography. American Express Portraits campaign named Print Campaign of the Decade by *Advertising Age*.

1991 Publishes *Photographs, 1970–1990* (HarperCollins). First museum exhibition, organized by the International Center of Photography in New York in conjunction with the Smithsonian's National Portrait Gallery in Washington, D.C. The exhibition travels widely in North America, Europe, Japan, and Australia.

1992 *Dancers: Photographs by Annie Leibovitz* published by the Smithsonian Institution Press.

1993 Makes portraits of people living with HIV for a San Francisco AIDS Foundation educational campaign. New contract with Condé Nast includes work for *Vogue* and *Condé Nast Traveler*. Receives an honorary doctorate from the San Francisco Art Institute. Makes first trip to Sarajevo to photograph the city under siege. "Annie Leibovitz: Sarajevo Portraits" exhibited at the Art Gallery of Bosnia and Herzegovina in Sarajevo.

1995 The Nippon Television Network Corporation sponsors the tour of "Annie Leibovitz, Photographs 1970–1990" in Japan and publishes an accompanying catalogue, *Annie Leibovitz, 1995.*

1996 Named official photographer for the Summer Olympics in Atlanta, Georgia. *Olympic Portraits: Annie Leibovitz* (Bulfinch) published.

1998 Moves into studio at 547 West 26th Street.

1999 *Women,* with an essay by Susan Sontag, is published (Random House). Exhibition of portraits at the Corcoran Gallery of Art, Washington, D.C. Inducted into the Art Directors Club Hall of Fame. Photographs a series of nudes for the 2000 Pirelli calendar. *Portfolio: Bibliothek der Fotografie #9, "Annie Leibovitz, 1968–1997,"* is published by *Stern,* in Berlin.

2000 *Stardust: Annie Leibovitz 1970–1999* published in conjunction with an exhibition at the Louisiana Museum of Modern Art, Denmark. Receives the Living Legend award from the Library of Congress. Receives Medal of Distinction from Barnard College. Wins three Alfred Eisenstaedt Awards for Magazine Photography, presented by the Columbia University Graduate School of Journalism. (Cover of the year: Jim Carrey, *Vanity Fair.* Single-image portrait: "The Sopranos," *Vanity Fair.* Fashion photo essay: Puffy Combs and Kate Moss, *Vogue.*)

2001 Photographs a series of landscapes for the Nature Conservancy. Images are published in *In Response to Place* (Bulfinch). First child, Sarah Cameron Leibovitz, born October 16.

2003 Donates a set of the photographs in the "Women" show to the permanent collection of the Women's Museum in Dallas, Texas. Receives Women in Photography International's Distinguished Photographer Award. Publishes *American Music*

(Random House). Exhibition opens at the Experience Music Project in Seattle and travels to the Rock and Roll Hall of Fame in Cleveland, Ohio; the Detroit Institute of the Arts; the Hospital in London; and C/O in Berlin.

2004 Susan Sontag dies on December 28.

2005 Samuel Leibovitz dies on February 3. Daughters Susan Anna Leibovitz and Samuelle Edith Leibovitz born May 12. Commissioned to document the construction of Renzo Piano's New York Times Building. Named one of the thirty-five Innovators of Our Time by *Smithsonian* magazine. The American Society of Magazine Editors names the January 22, 1981, John Lennon cover for *Rolling Stone* the best magazine cover of the last forty years. The August 1991 *Vanity Fair* cover of the pregnant Demi Moore places second.

2006 Decorated Commandeur in the Ordre des Arts et des Lettres by the French government. *A Photographer's Life* published (Random House). Exhibition debuts at the Brooklyn Museum and travels to the San Diego Museum of Art; the High Museum of Art in Atlanta; the Corcoran Gallery in Washington, D.C.; the Fine Art Museum of San Francisco; the Maison Européenne de la Photographie in Paris; the National Portrait Gallery in London; C/O in Berlin; Alcala 31 in Madrid; and Kunsthaus Wien in Vienna. The documentary *Annie Leibovitz: Life Through a Lens,* directed by her sister Barbara Leibovitz, premieres on PBS as part of the American Masters series.

2007 Moves into Greenwich Village studio. Commissioned to take the official portrait of Queen Elizabeth II. Marilyn Leibovitz dies on July 16.

2008 Named the San Francisco Art Institute's 2008 McBean Distinguished Lecturer. Receives an American Society of Magazine Editors' award for the 2007 *Vanity Fair* Hollywood Portfolio. Receives Urban Visionaries award for Visual Art from the Cooper Union.

ACKNOWLEDGMENTS

STUDIO 2008 *Karen Mulligan • Georgina Koren, Matthew Currie, Jesse Blatt, Laura Cali, Hasan and Baha Gluhić, Caroline Mitchell, Jenny Kim, Christopher Peregrin, Elizabeth Elsass*

ASSISTANTS *Nick Rogers, Paul Gilmore, Chad Riley*

VANITY FAIR *Graydon Carter • Jane Sarkin, Kathryn MacLeod, Susan White, David Harris*

VOGUE *Anna Wintour • Charles Churchward, Alexandra Kotur, Jill Demling, Grace Coddington, Tonne Goodman, Phyllis Posnick*

CONDÉ NAST *S. I. Newhouse, Jr.*

CONTACT PRESS IMAGES *Robert Pledge, Jeffrey Smith, Dominique Deschavanne*

KEN STARR & CO. *Ken Starr, Peter Lev*

WYLIE AGENCY *Andrew Wylie • Sarah Chalfant, Jeffrey Posternak*

ART + COMMERCE *Jim Moffat*

RANDOM HOUSE *Gina Centrello • Kate Medina • Frankie Jones, Lisa Feuer, Richard Elman, Benjamin Dreyer, Janet Wygal*

BOX STUDIOS *Pascal Dangin • Marion Liang, Catherine Gardère, Mamie-Claire Cornelius, Will Kennedy, Theresa Grewal*

AMILCARE PIZZI *Massimo Pizzi • Sandra Colosimo, Elena Gaiardelli, Cristiano Nardini, Barbara Sadick*

TEXT BASED ON CONVERSATIONS WITH SHARON DELANO

EDITOR *Sharon DeLano*
EDITORIAL AND PRODUCTION CONSULTANT *Mark Holborn*
PRODUCTION *Jesse Blatt, Laura Cali, Caroline Mitchell, Jenny Kim*
DESIGN SUPERVISION *Matthew Chrislip*
JACKET DESIGN *Ruth Ansel*

IMAGE CONSULTANT *Pascal Dangin*
COLOR AND SCANS *Box Studios*

DESIGNED BY JEFF STREEPER